ABOLITIONISTS, COPPERHEADS
AND COLONIZERS IN
HUDSON & THE
WESTERN RESERVE

ABOLITIONISTS, COPPERHEADS AND COLONIZERS IN HUDSON & THE WESTERN RESERVE

MAE PELSTER

Charleston London

THE
History
PRESS

Published by The History Press
Charleston, SC 29403
www.historypress.net

First published 2011

Manufactured in the United States

ISBN 978.1.60949.253.3

Pelster, Mae.
Abolitionists, copperheads and colonizers in Hudson and the Western Reserve / Mae
Pelster.
p. cm.
Includes bibliographical references.
ISBN 978-1-60949-253-3
1. Hudson (Ohio)--History--19th century. 2. Western Reserve (Ohio)--History--19th
century. 3. Antislavery movements--Ohio--Hudson--History--19th century. 4. Antislavery
movements--Ohio--Western Reserve--History--19th century. 5. Abolitionists--Ohio--
Hudson--History--19th century. 6. Abolitionists--Ohio--Western Reserve--History--19th
century. 7. Copperhead movement. 8. African Americans--Colonization--Africa. I. Title.
F499.H8P45 2011
326'.8097713609034--dc23
2011042385

CONTENTS

PREFACE

As I am currently working on my master's of fine arts in writing for youth and children at Vermont College of Fine Arts and a novel about the Underground Railroad here in Ohio's Western Reserve, my colleagues and professors all asked me if the Western Reserve still retains its Puritan character. My answer is yes. I know that in my childhood the values of free faith, free men, free speech and free press were solidly preached at home, at church and in the schools. In fact, when I came to Vermont to study creative writing, one fellow student wanted to know if I came from Connecticut. I whirled around at once and asked why she had asked me that question. Unfortunately, my keen interest in the answer embarrassed the lady, and she claimed she couldn't remember. One thing I do know is that the people of the Western Reserve use a good number of New England colloquialisms in their speech. This last summer at residency, a young man told me he loved my accent. So I guess I have my answer. The lady must have recognized the voice of Connecticut in my speech. So, yes, the people of the Western Reserve still bear the stamp of Connecticut.

This book was born out of curiosity. My husband and I had taken a three-day trip into northern New York State back in 1983. In the course of hiking the Genesee Valley, we became interested in America's early canal systems. When we came home, we learned about Ohio's canals. I spent a year researching them. I read about Alfred Kelley, the builder of the Ohio Canal, and his Quaker background, which may well explain Kelley's passionate assaults on the fugitive slave laws. I read about the Quakers of southern

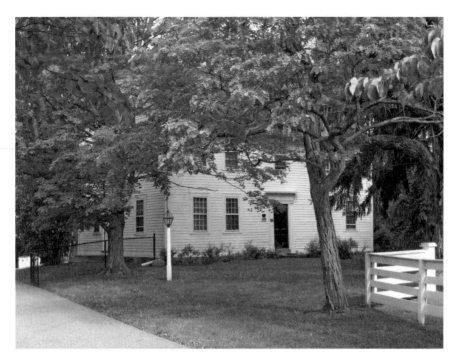

David Hudson House today. *Courtesy of William Pelster, photographer.*

Ohio. From there I read about the Underground Railroad and the part the canal towpath trails played, providing a tangible map to freedom for fugitives. My husband, Bill, and I spent a lot of time hiking the Cuyahoga Valley here in the Western Reserve. The deeper I went into the subject, of course, the more I learned. I learned things I didn't know about slavery, things I felt that others would benefit from knowing. I learned about the passionate civil rights disputes raging in Ohio's Western Reserve and the strong role Ohio played in defining freedom.

The thing to take away from all of this is that the question of civil rights and liberties were hotly debated in Ohio's Western Reserve. Today, many historians give the impression that the abolitionists had it right, but history shows that these people were too often hot heads dangerously willing to go outside the law. Others hid behind the laws and the status quo to have things their own way for their own benefit. Finding a one-size-fits-all solution wasn't as simple as it seemed. Slaves of mixed-race parentage added another dimension to the issues. Further, providing a place in American society for four million unskilled laborers posed huge difficulties. This was precisely

one reason why Europe dumped a large portion of their newly released serf population on American shores rather than find a place for them at home. Sure it was the right thing to do—to free the slaves—but you have to prepare to release a flood of people into the general population. Sometimes, you can't turn back the clock so easily. It just goes to show how hard it is to correct ingrained social inequities.

One might say that slavery was integral to feudalism in all of its forms. In fact, history dates it from as far back as 1700 BCE. It didn't begin and end on the west coast of Africa, and only three million of the twelve million Africans shipped into slavery in the Americas were shipped on British ships. Neither England nor America had invented the system of slavery. It was older—much older—and well established across the north and west coast of Africa long before European leaders began to take advantage of it. In a preindustrial age when major construction projects could only be accomplished with many hands through forced labor, it is understandable that the powerful used slaves for such work. It wasn't the kind of thing a person would volunteer to do. I believe that as horrible as slavery was and is, there was greater acceptance of these labor practices in the time before steam-driven equipment, before the Industrial Age; however, as science made the choice to do without slave labor available, other reasons like distribution of wealth and the need to feel superior to poor, friendless people dominated. The powerful were quick to identify and seize upon exploitable populations, unwilling to give up the social controls that made them wealthy.

But there is some comfort in the fact that issues of emancipation were on the table right from the beginning as the Founding Fathers wrote the American Constitution. Slavery was not something our nation's forefathers simply accepted. Thomas Jefferson wrote the equality of all men into the Constitution quite deliberately, suffering lifelong frustration that he had been forced to alter the passage and apply it strictly to white men. Already, the roots of slavery had spread so deep, far and wide that they posed a nearly impassible barrier to freedom. It is chilling to realize that the South's plan was to expand slavery through the Caribbean into South America and across the breadth of North America, enlarging it to include laborers of all races and ethnicities. The vision of an enslaved Western Hemisphere is too horrifying to contemplate.

Nevertheless, the passions of emancipation burned brightly in Ohio and particularly in the Western Reserve. The citizens of the town of Hudson, along other with settlements in the Western Reserve were in the thick of the fight for freedom. The original settlers influenced the foundations of

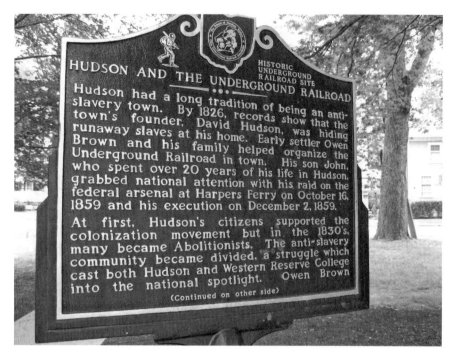

Underground Railroad marker. *Courtesy of William Pelster, photographer.*

civil rights in this nation. From the beginning, there were people here who argued universal freedom for all men and women in America. They were willing to speak out publicly for what was right and to step forward in the defense of their neighbor, of the oppressed and of those wronged by the status quo. Defining the parameters of freedom and what that looked like in terms of suffrage and citizenship, in terms of employment, in housing and in education was not always simple. Economics always play a role in the political process. But the people of the Western Reserve were actively engaged in defining those freedoms that we nowadays take for granted as rights. That doesn't mean that the issues of true fairness are carved in stone or settled. Slavery still exists in today's world. What it does mean is that freedom is something that must be defended, defined and redefined in a complex world of competing values and interests. It becomes a continuing conversation that all Americans must contribute to, just as our Puritan forefathers here in the Western Reserve did.

The Hudson Library and Historical Society website gives an illustrated list of Underground Railroad sites in Hudson, Ohio, compiled by Hudson's

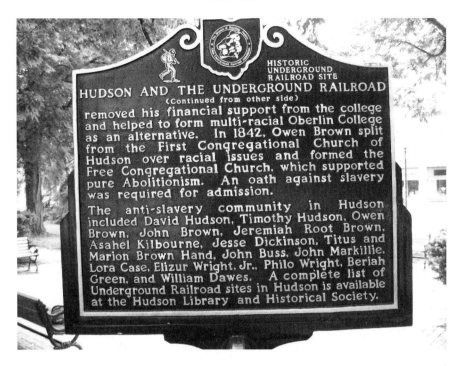

Underground Railroad marker. *Courtesy of William Pelster, photographer.*

beloved librarian James F. Caccamo at http://www.hudsonlibrary.org/
Historical Society/UGRRHudson.html. On the historical society link at the
Hudson library website, the reader will also find information about Hudson's
historic houses, a virtual walking tour and a walking tour of Hudson
brochure; however, as a note of correction, I must add that the Elizur Wright
Jr. House is found at 120 Hudson Street. Dr. George P. Ashmun lived at 29
Aurora Street, and Judge Van Rensselaer Humphrey's home is found at 264
North Main Street.

My thanks go to Mrs. Dye, librarian of Hiram College, and David Everett,
director of Hiram College Library. Also, very special thanks goes to Hudson
Library and Historical Society archivist Gwen Mayer and volunteer Nancy
Brock, both of whom went to great efforts to help me run down elusive early
documents both in Hudson and in the Archives of Cuyahoga County, Ohio.
I also want to thank current Hudson residents of the Humphrey house Ann
and Roger Engle for sharing their *Revised Final House Report* with me and giving
me permission to quote this work. Thanks also go to Martin Hauserman,
chief archivist for Cleveland City Council since 1985 and the chief city

archivist since 2002, for telling me where early documents I was looking for were to be found. My thanks also go to Joseph S. Wood, professor of the Division of Legal, Ethical and Historical Studies at Yale Gordon College of Arts and Science and provost of the University of Baltimore—also a graduate of the Western Reserve Academy here in Hudson that occupies the grounds that was the setting of the Western Reserve College—who gave permission for me to quote from his article "Build, Therefore, Your Own World": The New England Village as Settlement Ideal." Thanks go as well to my husband, William Pelster, who served as my photographer—he truly worked a few miracles with some of these photos that were old, faded and extremely small. I am grateful for the services of Cleveland State University Archives, which provided me with the etching of Alfred Kelly. Thanks go too to Case-Western Reserve Archives, which shared its portraits of Beriah Green and Elizur Wright Jr., and, of course, the Photo Duplication Services offered by the Library of Congress.

Summer is a great time to come see Hudson. From Memorial Day on, there's plenty to see and do in this little sprout of Goshen, Connecticut. Hudson Festival Days in June with the Home and Garden Tour offer the opportunity to get a look inside historic homes. There are art shows, wine tastings, barbecues and showcasing of local cuisine, the ice cream social and antiques—the lot. The chamber of commerce puts out an annual visitor's guide on its website at http://www.explorehudson.com/Visitor_Guide.asp. For students of the Underground Railroad, there's a lot to see of historic interest while enjoying the many attractions of modern-day Hudson.

CHAPTER 1
THE LAND AND THE PEOPLE OF THE WESTERN RESERVE

Horse hooves thundered toward Tannery Acres and across the bridge leading into Hudson Village. Two runaway slaves sheltering with John Brown and his wife, Dianthe, looked up from supper, their eyes pleading with their young hosts for aid. Without hesitation, says John Brown Jr., his father pressed weapons into the fugitives' hands and led them out the door of his house, down the knoll and past the orchard into the swampy hollow where a brook supplied his father's tar pits. There they waited in the dark woods in terror of their freedom.

The incident proved a false alarm, but it was one John Brown's young son never forgot, and it truly captured the character of the strong abolitionist town of Hudson, Ohio, in the Western Reserve of Connecticut. It was the first time the boy had ever seen a "colored" person, and it was hard to say which of them had been the most traumatized by the event. The boy was certain that the kiss the slave woman gave him would stain his cheeks black like his mother's kettle. So he ran away from her and tried to rub off the kiss. Suffice it to say, that when John Brown Sr. went to call the runaways back into the house, he claimed that he tracked their location by the beating of the terrified man's heart.[1]

John Brown wasn't the only resident of Hudson whose heart was sensitive to the passions of emancipation. While it was actually unusual for runaway slaves to pass directly through the village of Hudson, it was not unusual for village residents to take a vigorous interest in this cause. Hudson librarian James F.

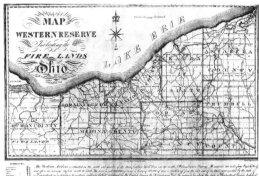

Left:Map of the Western Reserve including the Firelands, dated 1826. *Courtesy of Cleveland Public Library.*

Below: Tannery Acres. *Courtesy of Hudson Library and Historical Society, photographed by William Pelster.*

Caccamo's manuscript, posted on Hudson Library and Historical Society's website, shows nineteen Underground Railroad sites in the village of Hudson where escapees could find support and aid.[2] It was well known that once an escaping slave made it to the Western Reserve portion of Ohio, that it was rare for an owner to recover his property because the original settlers insisted that slavery be made illegal in the lands of the Western Reserve right from the beginning. With the nation fresh from the American Revolution and the signing of the Declaration of Independence, these people had been active participants in America's fight for freedom. They connoted the Negro's fight

for emancipation with their own quest for independence. Where southern Ohio was strongly influenced in the national debate regarding slavery by trade with the South and economic competition in the labor force from free blacks, the Western Reserve viewed the matter strictly as a moral question regarding what was right and what was wrong. That all men were created free was a matter of faith that these settlers took seriously. Men like Squire David Hudson, founder of the village of Hudson, and John Brown's father, Owen Brown, were among the first to harbor escaping slaves in the eastern portion of the state, becoming stationmasters on the Underground Railroad. This stance was directly tied to the community's Puritan heritage, and it is why Hudson's contribution to the fight for freedom was so unique—but then the Ohio counties constituting the Connecticut Western Reserve are unique for a number of reasons.

The Western Reserve of today exists as a function of the fact that English monarchs had a poor sense of geography and a high sense of entitlement. Like Caesar, they sent their emissaries who raised the king's standard on undeveloped land and declared it belonged to the British crown, even if they didn't know precisely who lived there or whether there might be any objection from these inhabitants. As far as the British were concerned, aboriginal peoples had no property rights that need be respected, and land existed to be developed for economic gain. So with sweeping statements, like "from sea to sea," Charles II of England granted to the original Connecticut colony an unknown amount of property because no one had any idea how much land lay between the two seas, or, in fact, which two seas the king was describing.[3] On top of it, he managed to give Connecticut a fairly large portion of Pennsylvania by logistical error, and this would become a bone of contention between the two colonies. An Indian massacre of British settlers attempting to colonize the Wyoming Valley—that lay in eastern Pennsylvania or in Connecticut, depending upon your viewpoint—settled the matter, at least for a while.

But after the American Revolutionary War, the original colonies were asked to turn back to the newly formed United States' government the land granted to them by the British crown. This was done in the name of the Union and in part to pay off war debts. With reluctance, therefore, state after state relinquished their vaguely stated property rights for something more substantial—clearly defined boundaries and a centrally financed national debt. After this, the federal government would define state and territorial boundaries; however, Connecticut, in its stubborn Puritanical way, held out for compensation—compensation for the theoretical property that may have

belonged to Connecticut if the original land maps had accurately reflected the state's claim and compensation for the blows the state received during the American Revolution. Many Connecticut farms and towns had been burned to the ground by British troops, and so the validity of the state's claim to more land seemed reasonable to the new American Congress. These Founding Fathers of Connecticut reserved land from their original grant on the far side of Pennsylvania's western border for themselves, and eventually, Congress agreed. The reserved property consisted of approximately three million acres, a portion of which happened to lie under Lake Erie and was roughly equal in size to their original colony.

George Washington, in a letter to William Grayson in Congress, expressed his dislike of Connecticut's proposal to reserve land in the Ohio Territory because it granted portions of northern Ohio to the people of Connecticut in a way that was given to no other people in the formative nation.[4] It gave the land of northern Ohio to the powerful state of Connecticut and without supervision of the high court of the new nation, like a legal award belongs absolutely to a wronged party. The land became the property of the state of Connecticut in a deeply personal way. He worried, and rightly so, that Connecticut would set up a land company to sell this valuable land for private gain. The arrangement created somewhat of an anachronism, which is why Connecticut's Western Reserve in Ohio is sometimes referred to as a state within the state of Ohio. The whole point of turning back jurisdiction to the newly formed United States' government was to create a central authority so that there would be no competing land claims, such as had happened between Pennsylvania and Connecticut. Further, the federal government would be losing the potential revenue the land of the Northwest Territory might generate. Still, Connecticut determined to press its claim. Crushed along the Atlantic coast, the settlers of New England were running out of land to till and support a burgeoning population. The people of Connecticut needed more land for their progeny.

Grayson replied to Washington, saying that there must be sacrifices made to maintain "public tranquility."[5] What he meant, of course, was that Connecticut was not through fighting for its rights. His argument was that:

> *Connecticut would settle* [the Western Reserve] *immediately with emigrants well disposed to the Union, who would form a barrier, not only against the British, but against the Indian tribes still living there; and that the thick settlement they would immediately form would advance the value of the adjacent country and would facilitate emigrations thereto.*[6]

As it was, Washington and his friend, Alexander Hamilton, already had cause for concern regarding squatters settling along the north coast of the Ohio Territory along Lake Erie, stirring up relationships with indigenous Indian tribes. It seemed Grayson was right and that the government should move quickly to secure its interests without quibbling over trifles with the state of Connecticut. So, eventually, Washington was convinced to go along with the deal because it would place Revolutionary War veterans, still in their prime, along the north coast border. This proved a good decision because the feisty scions of the Nutmeg State were out there on the northern Ohio border ready and waiting for the British when they came down from Canada in 1812 in an attempt to reclaim the Northwest Territory. Every able-bodied man, except for the few left behind to guard the women and the children from the possibility of Indian uprisings, rushed north at once to defend the town of Cleveland from assault, while the women, reports Emily Metcalf of Hudson village, "melted their precious pewter plates into bullets and [sent]

Emily Metcalf. *Courtesy of Hudson Library and Historical Society, photographed by William Pelster.*

away their husbands and friends with a god-speed to fight for their hearth-stones."[7] In other words, the patriots of Connecticut would earn their place in the Western Reserve twice.

Meanwhile, the state of Connecticut wasted no time in acting upon its declared ownership of the land. Not waiting for Congress to act, it started out as the state meant to go on. As Washington foresaw, investors began by setting up a land company complete with shares and trustees. Its purpose was to purchase the land of the Western Reserve for resale to settlers, and an effort was made to limit such sales to citizens of the original Connecticut colony. A half million acres of the western portion of the reserve was set apart for those who had suffered losses by fire at the hands of the British—people whose original Connecticut towns of Danbury, Fairfield, Greenwich, Groton, New Haven, New London, Norwalk and Ridgefield had burned to the ground in the war. This land became known as the Sufferer Lands or the Firelands. All across the north coast of the Western Reserve, place names reflecting the origins of these sufferers emerged as a New Connecticut was born in Ohio. Soon, the names of Revolutionary War heroes, military officers who had been given grants of land as an inducement to settle in the Western Reserve, appeared throughout the territory on budding communities and landmarks. The result was that the Western Reserve duplicated and conserved the New England these settlers had left behind, like something preserved under glass but with a twist.

These people had a strong sense of their place in history. They were nation builders, and they knew it. The path that their ancestors had gone down, separating themselves from crown and state religion to take that individualistic outlook halfway across the globe and live as they saw fit, would inspire a new vision of life in America. The opportunity to mold the look and character of the new nation was their inheritance. They saw it as their duty, like Moses leading Israel to the Promised Land, and the social/political/faith structures they built in the Western Reserve would eventually influence the cultural development of the entire nation. It was a destiny they took up with both hands, a strong will and a strong back. On the way, their faith in God's leadership of the project added a sense of spiritual blessing that sustained them through all the backbreaking, body-crushing, life-snuffing labor. They'd been allowed the chance to build a new England here in America, an England where all men would be given equal respect and equal opportunity—at least, that was their ideal. They saw themselves as a newly chosen people—chosen by God to spread Christianity to this virtually untouched soil. No need to look backward again. Here, in a place

that would be also called one day the Heartland of America, they could prove the validity of their Puritan philosophy of life and faith, and they built on a firm foundation. Traveling west to virgin territory where at the foot of the Appalachian hills the land spread out in gently rolling acres, they found the soil perfect for farming once the massive forests were leveled. The terrain was also conducive to urban planning at a level that had never been achieved in the original colony where their forefathers had been crushed together along the coastline of New England. Once enough trees had been felled for a town center and a few crops planted, they could intentionally design the look and function of their settlements, and they had a fine eye for designing practical living space.

Interestingly, the profits of these land sales were not kept for private use as Washington had anticipated. The Connecticut forefathers of the Western Reserve set their profits from these sales aside to support public education in the state of Connecticut perpetually. In other words, they made sure that those who should benefit by this land award did. Emphasis on education was typical of their Puritan forefathers because "the true descendant of Puritan stock marches with a Bible in one hand and a school book in the other."[8] This is the kind of people they were: they were direct descendents of the original Puritans, and the Western Reserve became an outpost of Puritanism in America. In fact, one of the Connecticut Land Company's trustees, Samuel Mather, was a direct relation of Cotton and Increase Mather. In the Western Reserve, these Mather descendents and leaders like them would stand at the center of educational institutions, cultural centers, political structures and charitable organizations. These men didn't intend to transport old Connecticut to the new Connecticut of the Western Reserve in its entirety, but they laid the foundations of the communities to come that would reflect an idealized vision of the character of their Puritan forefathers in their sense of community, their emphasis on faith that was tolerant of the beliefs of others and their appreciation of the importance of public education and democratic government.

Further, the trustees of the Connecticut Land Company were not only careful to sell the available land almost exclusively to Connecticut citizens—with only two exceptions from Massachusetts—they made efforts to confine those sales to those of good Puritan character, faith and descent with the same care that their forefathers took to select candidates for the *Mayflower* venture. These New Englanders, who came from the hotbed of liberty and equality where the first blood in defense of freedom was spilt, were scattered evenly and intentionally across the land of the Western Reserve that they surveyed

into rectangular blocks, producing a framework for development. Likewise, the qualities and ideals of their forefathers came with these early settlers, qualities that emphasized civil and religious liberty. They were proud of the activism that had bought the nation freedom and independence from state religion and hereditary privilege. They were descendents of people who had defied the power of the crown and the established church to follow their own Christian conscience, people who were unafraid to speak their mind and stand by their own personal truth. From the pulpit and in their schools, they preached free thought, free men, free speech and free press. These ideals were quickly reflected in their energetic replication of the best elements of Puritan society: a democratic congregational church structure, provisions for common schools, democratic town elections promoting centralized government and a reverence for the Sabbath and for high moral standards.

It was this very independence of thought that originally convinced Elizabeth I of England and her successor, James I, to rid England of these rebels because they would not accept the oversight of bishops or the monarch in their religious observances, neither would they sit quietly in parliament voting as they were told to vote. Both James and Elizabeth realized that the Puritans would soon see no point in having a monarch at all, which is precisely what eventually came to pass in 1776. Still steamed up by their victory, they weren't about to surrender their newly established freedoms in the Western Reserve either.

They came to the Western Reserve with a distinct purpose. The idealistic picturesque villages these families built were intended as an experiment in "reform[ing] human interaction."[9] The venture emulated the works of their God in creating the original Eden: their intent was to build a new Eden on American soil. Gone was their forefather's plan of growing a strong economic, religious and political structure that they would one day take back to England as rulers. The Revolutionary War killed that dream; they burned that bridge. Now, they wished to alter the pattern of settlement they'd known in the original Connecticut colony where people lived as isolated individual farmers and build their envisioned kingdom here, permanently, in the Western Reserve. These settlers constructed villages formed after the English model with a defined town center, a church and a school, built on a firm foundation of calculated urban planning, a "metaphor for inherited ideals of stable Puritan community."[10] This ideal depended on shared values and communal networks to bind them together in a single purpose where Protestant ethics and principles of enlightenment sustained one another. The solid social gridwork they laid down survived the influx of European

David Hudson. *Courtesy of Hudson Library and Historical Society, photographed by William Pelster.*

immigrants recruited as labor in America's industrial north and the floods of Negroes heading up from the Dust Bowl and in the Depression. Through these founders' carefully planned cultural institutions, their ethics and standards of conduct would be communicated, cultivated and sustained in these newcomers.

It was such an idealistic vision of Christianity, enlightenment and democracy that caused forty-year-old David Hudson of Goshen, Connecticut—a born-again Christian of Calvinist bent—to bring his family to the wilderness of the Western Reserve of Ohio. Many others like him would follow. His desire was to hollow out of the wilderness an ideal Christian society. Hudson's confession of faith published by the New York Missionary Society describes a troubled early orientation to Christian faith. Originally, his father had been a member of the Calvinist Congregational Church when a brush with Anabaptists unsettled his faith and his children's religious upbringing. This was further complicated by his father's later conversion to Quakerism when Hudson was a teenager. Naturally a difficult time between parent and child, adolescent rebellion could have been predicted. Hudson says that his father's inconsistent faith confirmed and "increafed [*sic*] fuspicions of the truth of *all* religion."[11] Putting a child to the work

of unlearning a carefully memorized catechism is bound to cause parent/ child dissentions. Understandably, this triggered an interest in disproving scripture in the face of his father's dogmatic, fluctuating ideals. For quite some time the young man struggled unsuccessfully with the philosophies of his age. It was the Era of Enlightenment augmented by the rise of scientific exploration, and Hudson studied all of it. Like many of his generation, he was particularly fired by the writings of Thomas Payne. He found himself toying with atheism and balancing all these things against the principles of freedom. A well-read, liberally educated young man, he decided that a God devoted to taking all the joy from life was not for him. Unfortunately, as he would later point out, this left him with a doctrine of hedonistic nihilism to which he felt unable to reconcile himself in the end.

Over time, Hudson became convinced that Christianity was an essential component of enlightened civilization and decided to take a fresh look at it. Finally, he was able to speak with the Reverend Mr. Hooker to regain his faith; however, his pride stood in his way. As Hudson put it, "I had lived a long time in the profeffion of infidelity, and could not willingly meet the fcoffs of all my neighbors."[12] This natural reluctance to be seen as an idiot would lead him to "remove [himself] to the folitary wilds of the Connecticut weftern referve and there commence a life of religion, where [his] former way of thinking was unknown."[13] Connecticut's loss, therefore, became the Western Reserve's gain. He wouldn't be the first to make this trek or the last.

It was a huge and dangerous task that Hudson was undertaking, and he was deeply sensible of the hazards of frontier living: He knew that "no considerable settlement had been made but what was established in blood," and that he was putting the lives of his wife and children on the line, along with those of the other families from Goshen, Connecticut, who had chosen to join him. Further, he was not exactly a young man any more.[14] The land was untamed and filled not only with game but also poisonous serpents as well. Fat rattlesnakes filled the Cuyahoga River Valley just west of the land he'd purchased, and it was said that a man could hardly set his foot to the ground there without stepping on one. His journal accounts describe the role his newfound faith played in sustaining him, and until an ordained minister was found and/or could be afforded, he took the role of spiritual leader for his party.[15] To these settlers, once basic shelter had been established and a few staple crops were in the ground, faith came first. Services were held in private homes, and a log cabin was soon constructed in the Hudson town center to serve as a church, school and town meeting place.[16] Swiftly, faith, education and democratic town government came together. It was a pattern

of settlement organization that would be reflected by other "stations," as they were called, developing on the northwest frontier.

But there's no such thing as paradise, even on virgin soil with a population of like-minded Puritans. Along with these missionary minded settlers, the squatters Washington and Hamilton had feared also appeared, looking to take advantage of any lack of governmental supervision. The need to establish law and justice soon became evident. In 1800, when the state of Connecticut finally ceded

Mary Hudson. *Courtesy of Hudson Library and Historical Society, photographed by William Pelster.*

control of the Western Reserve to the new American government, "David Hudson boldly wrote Arthur St. Clair, Governor of the Northwest Territory, asking to be made Justice-of-the-Peace in Hudson."[17] As good roads were established under Hudson's supervision and mail service commenced, "[Hudson] had himself appointed Postmaster of Hudson" as well.[18] By 1802, a subscription library had been established through the efforts of David Hudson and George Kilbourne. That "these books were selected by the President of Yale College and other literary men in New Haven, Connecticut" demonstrates the deliberate transplantation of New England culture and education to the Western Reserve.[19] So that while they had left Connecticut behind and were eager to erase the mistakes of the original colonials, they brought the best that their ancestors had to give in terms of culture and advice with them.

From the beginning, these transplanted Puritans understood the importance of education in promoting high principles. They believed in the Calvinist theology of an elect class of Christians and that through their actions and how they lived their lives they would demonstrate before men their worthiness as members of this class—worthy of heaven itself. This Christian character, they believed, would rise from their own hard labor and

obedience to biblical principles. They believed that God's approval of their efforts would manifest itself to the world by means of growth and economic prosperity. In other words, they ascribed to the theorem of life called the "Protestant Work Ethic." They called it the "Connecticut Spirit," and from this attitude sprang their intense devotion to the principles of freedom. Yes, faith was a central component of their lives; nevertheless, they believed in democratic nonecclesiastical government, or separation of church and state, along with values that would promote equal opportunity to all the citizens of the Western Reserve. Their goal was to promote a society free of the aristocratic social structures of English society that they expected to foster through centralized public education.

This concept of public education on a grand scale was revolutionary in itself. The British upper crust had always hoarded education. It had always been a privilege of wealth and rank, but the Puritans of the Western Reserve meant to make public school education a right of citizenship, even if nobody knew quite how to fund it. They knew that lack of education presented a barrier to economic growth and created class divisions. Further, the need to establish schools fast became evident, as the children of Yale scholars, who had made a patriotic choice to come west and hold down the land of the Western Reserve against the British, found their own children in want of such education and all too quickly turning into untamed little savages. Therefore, the citizens of the new state determined that all would enjoy a common public school education in Ohio. To this end, small people's colleges or quasi-public academies soon appeared, one of them in the village of Hudson.

A number of towns wanted to host such a school, but Hudson was chosen for a number of reasons. At the time, there was a great prejudice against creating institutions of higher learning near an active seaport, such as Cleveland. The primary objection, born of Connecticut experience, was of the corrupting influences and disruptive natures of sailors whose usual modes of amusement were well known to the Nutmegers. Hudson's proximity to good main roads linking it to Pittsburgh, Cleveland, Oberlin and the then state capitol of Chillicothe would make it simple for parents to ferry their sons to college. The distance from sailing adventurers was considered a plus. In short, it appears to have been the consensus of elder thought that there was little opportunity for the young to run amuck in the village of Hudson. They were in the center of everything and yet a good distance from anywhere a young person might go to get into trouble. David Hudson ran a tight ship: parents could feel at ease regarding campus security.

As early as 1825, therefore, David Hudson became the father of the Western Reserve College, forerunner of today's Case-Western Reserve University, when he donated 160 acres and the town approximately $7,000 in cash to the project of creating a new collegiate institution in the Western Reserve. The trustees would be Presbyterian/Congregational Church members and ministers. The new institution's purpose was to promote conversation regarding public, political and social issues of the time, encouraging the youth of the Western Reserve to develop a public conscience—an education that included preparation in the liberal arts' professions and in the sciences. Their express design was to "educate pious young men as pastors for [their] destitute churches, to preserve the present literary and religious character of the State, and redeem it from future decline; to prepare competent men to fill the cabinet, the bar, and the pulpit."[20] This was not learning for learning's sake alone, but learning with a view to producing leaders in every profession—leaders who would take their place at the heart of the nation's ecclesiastical, legislative and economic/business structures. Their vision was that they and their descendents would become key participants in forming policy in the Western Reserve and in the nation. The college would become known as the "Yale of the West" and was the brainchild of trustees who were graduates of Yale, Williams and Dartmouth Colleges who wanted to be sure that the youth of the Western Reserve would receive an education equivalent to the ones their forefathers enjoyed. In fact, the ministers who became associated with the college almost all came from New England colleges. This college fostered the sort of freethinking that would eventually make the village of Hudson a hotbed of abolitionism and a dutiful child of the freethinking David Hudson. As a result, Hudson soon became known as a center of abolitionist sentiment in the Western Reserve. It was a pattern that echoed across the region and from there to the rest of America.

What the institutions of the Western Reserve did not do, though, was to link their dominant religious affections directly to law, government or schooling. The principle of separation of church and state was absolute in the Puritan mind. So that no matter how thin the line between faith and patriotism, government and politics was a thing kept separate, and the principle of freedom of religion would allow space for Christian variations such as the Shakers that settled near Cleveland and believed that "the advent of Mother Ann was the second advent of Christ in the form of a woman and that the Godhead consists of the motherhood as well as the fatherhood of God...[that] God is dual, —both male and female."[21] The Shakers, who preached a celibate life, would devote themselves to the care of orphans.

Other, more eccentric characters like Lorenzo Dow would claim divine and personal communication with God. Dow advertised in April 1827 that he would hold religious services on the banks of Lake Erie near Cleveland on July 2 of that year. When he arrived as appointed with a coat over one arm and carrying a staff like Moses in the other, he told the crowd that "[he had] a commission from Heaven to cast out devils, of which [he] fear[ed] some of [them] were possessed."[22] This eccentric preached and went his way, often making appointments to preach halfway across the country years in advance, but "Crazy Dow" always kept his word, and so he was well tolerated in the Western Reserve. Here, in the early years, Presbyterians and Congregationalists worshiped together in cooperation until the 1830s. Many of these early settlers were highly educated people able to look beyond structured catechisms and faith hierarchies. They were scholars, missionaries and liberally educated men, nearly all with a strong social conscience.

Early newspapers are filled with letters to the editor hashing over the social questions of their day. Everything from relationships with Indian tribes and the civil rights of these Native Americans to temperance issues and women's right to vote were argued at length. In fact, the question of the government removing Native Americans from Ohio and moving them west was hotly debated in the Western Reserve because the settlers there were acutely aware of the debt they owed to these Indians. They would never have survived their first winters in the wilderness without the kind support they received from them, viewing them as friends and neighbors.

At the far end of the Western Reserve, Oberlin College would open their doors to African Americans and to women. People across the nation soon became familiar with the names of abolitionist crusaders like Benjamin Franklin Wade, Joshua Reed Giddings, Charles G. Finney and Theodore Dwight Weld, whose works inspired Harriet Beecher Stowe's *Uncle Tom's Cabin*. It was at the Western Reserve College that Frederick Douglass would be invited to be the first African American to address a college graduating class as the commencement day speaker. All this was possible because of the unique forward thinking of the people of the Western Reserve. The Congregational church at Hudson hosted numerous like-minded preachers, and it was here that young John Brown grew to mature Christian stature. It was no surprise, therefore, that the population of the Western Reserve—who had the principles of freedom drilled into them in school, in church, in the local newspapers and by their families—strongly supported the work of emancipation.

CHAPTER 2

BLACK LAWS AND THE EVOLUTION OF THE UNDERGROUND RAILROAD IN OHIO

When slave catcher Joseph Keeler was arrested by lawmen just south of the town of Hudson in May 1820, he must have been very surprised to find himself charged with kidnapping and facing a federal grand jury five days later. In Keeler's eyes, he was on the side of the law, just making an honest living returning stolen property; in practice, he was in the heart of abolitionist territory where the black laws of Ohio were routinely ignored or evaded. The authors of those laws, with their blatantly Southern sympathies, had forgotten one important thing. They didn't speak for the people of the Western Reserve, and the concept of a trial by jury was one to which the Nutmegers felt every man was entitled. True, the two fugitive slaves that Keeler had captured—Martin and Sam by name—had no right under Ohio law to even speak in court on their own behalf, let alone the right to a jury trial, but the Nutmegers weren't charging Martin or Sam with anything. They had found a way to bring matters home to the slave catcher, and kidnapping was a jury offense. The case was referred to the Cleveland Court of Common Pleas and heard before Judge George Tod. Alfred Kelly, Cleveland's first practicing attorney, a member of the Ohio House of Representatives and the village of Cleveland's first president, or mayor, was the prosecuting attorney. Reuben Wood, who subsequently became one of Cleveland's early mayors, and Samuel Cowles defended Keeler. The *Wellsburg Gazette* and the *Independent Virginian* of Clarksburg, Virginia, called the trial a mockery, but the whole purpose of a jury trial is to measure public standards of conduct regarding rules of law, and the Puritans of the Western

Reserve had their own code of conduct when it came to fugitive slaves. The jury voted their convictions, finding Keeler guilty of kidnapping.[23]

While Ohioans of today are proud of their status in the fight for civil rights as a slave-free state, and the state's geographical positioning helped more fugitive slaves escape than any other state in the Union, not all Ohioans supported this abolitionist stance. It is true that slavery was made illegal under Ohio's first constitution as early as the Ordinance of 1787, but it is also true that the ordinance provided for the return of any fugitives from slavery who might cross into the Northwest Territory in pursuit of freedom. Further, Southern congressmen influenced that contract to their own economic benefit and to promote the slave owner's cause. William Grayson, in writing to President James Monroe, explained that "the clause respecting slavery [in Ohio] was agreed to by the Southern members for the purpose of preventing tobacco and indigo from being made on the northwest side of the Ohio [River]."[24] These crops were lucrative and foundational to the Southern economy, but the South believed that they could only be feasibly cultivated with slave labor because these crops required constant year-round attention; however, they were well aware that Ohio's climate was able to support this type of agriculture. So in approving Ohio as a slave free state, they were also denying Ohio the ability to grow these profitable crops. In other words, while the antislavery clause in the Ordinance of 1787 pleased the people of the Western Reserve and was clearly a step toward the emancipation of the Negro, it was not done for the benefit of the Negro nor was it included in deference to the moral codes of the Nutmegers. It was done to preserve and protect the economy of the South.

Any doubts as to the intentions of Congress regarding Ohio's slave-free state was put to rest by the laws that followed. From the start Ohio legislators, influenced by their business connections with the South, ensured that the laws of the new state provided no enticement to freedom. The idea that slaves might cross the Ohio River and become free when their feet touched Ohio soil was unacceptable—both to the North and to the South but for different reasons. The slave owners of the South had a great deal of capital tied up in their slave labor force because slave ownership was a cash business. Nobody sold slaves on credit: the purchase of slaves required cash. In a time where cash was a rarity, these plantation owners were extremely sensitive regarding their personal investment in the slave labor system; Ohio was concerned by the possibility of becoming overwhelmed by penniless, desperate, illiterate people who could contribute nothing to the state's economy. Neither did Ohio

wish to become a dumping ground for the South's aging slaves, as a number of slave owners anxious to set free their slaves were actually purchasing land in the Northwest Territory with the intention of sending their slaves there as free men. That these people would compete for laboring jobs with white men in the new territory was another drawback. Therefore, both the North and the South had a stake in making sure that Ohio's laws made the African uncomfortable and unwelcome in the lands north of the Ohio River. These laws became known as black laws. Nonslave-owning Southerners who had moved north because slave-owning planters had no use for free men as laborers threw their influence behind these laws to protect their newfound livelihoods, outvoting the New Englanders of the Western Reserve.

The object of Ohio's black laws was to legislate a near-slave existence for Ohio Negroes whatever the original ordinance said to the contrary. The members of the Ohio Constitutional Convention meeting in the state capital decided that the Ordinance of 1787 applied to the Northwest Territory, not to the new state of Ohio and in doing so appropriated broader powers in deciding the social/political position of Negroes in Ohio. The representatives played with the idea of giving the ballot to Negro residents until the idea of a Negro giving testimony in court against a white man overset their better judgment. Also an apprenticeship provision was included in the new state constitution that amounted to the reenslavement of free Negroes living within the state. Many free blacks were impelled to indenture themselves when employers would neither hire them nor teach their children a trade unless they signed an indenture contract, despite the law that stated:

> *Nor shall any male person arrived at the age of twenty one years or female person arrived at the age of eighteen years be held to serve any person as a servant under pretense of indenture or otherwise unless such person shall enter into such indenture while in a state of perfect freedom and on condition of a bona fide consideration received for their service.* [25]

All this provision did was to encourage the importation into Ohio of black children as domestic labor because they belonged to an unprotected age range.

Additions to the law demanded that free Negroes living in Ohio post a $500 bond at a time when very few white settlers could have produced such an amount of cash. This concept stemmed from England's vagrancy laws and was put into place to insure that Negroes coming to Ohio had no need to apply for public assistance. Therefore, blacks living in the state were required

to register with the state, prove their free status and post a bond in proof of their fiscal solvency, a thing not required of white settlers. Employers who used black labor needed to prove their workers' free status or be fined heavily. When it came to public education, poorhouses and orphanages, the Ohio Negro need not apply. They also couldn't serve in the Ohio military, on juries or testify on their own behalf in court. When the fugitive slave laws allowed bounty hunters to follow fugitive blacks into Ohio for the purpose of returning them to their owners, warrants were deemed unnecessary because the white man's claim was all that was required, and for too long the state looked the other way when the children of free blacks, who were too young to speak as to their free status, were kidnapped and sent south for sale by these unscrupulous hounds. It was only when white citizens in southern Ohio became alarmed that white children with brown eyes and brown hair were also being targeted that attitudes changed. As early as 1830, the Ohio Senate was discussing the matter. They hadn't expected bounty hunters trespassing on Ohio soil without a by-your-leave and appropriate respect paid to the local constabulary. Few minded when slave catchers targeted Irish immigrants and their children, but when children of citizens of good English descent were kidnapped and sold as slaves that was a step too far. Concern for the children of white men drove the conversation.

In short, the notion that Ohio was a slave-free state isn't strictly true. For one thing, the Ohio Constitution did not emancipate the slaves that already lived within Ohio's borders. Those already residing in the state that owned slaves were under no obligation to free them. What was illegal was importing more slaves into the state, with the exception of minor children. The indenture of black laborers was perfectly permissible because, allegedly, indentured servants weren't slaves. A great many free blacks had to submit to indenturing themselves rather than starve. Many Negro parents were obliged to indenture their minor children in hopes, at least, of the child learning a trade when most public schools were closed to them, the only real exception being the public schools of Cleveland, Ohio, in the Western Reserve. Frank Uriah Quillin tells us in his book *The Color Line in Ohio: A History of Race Prejudice in a Typical Northern State* that the city of Cleveland "was given its charter in 1835 and in this charter was stated that the schools were to be accessible to white children. The Cleveland authorities never [enforced] the word white but admitted the [children of] colored [residents] of whom there were always comparatively on equal terms with the whites."[26] Nevertheless, there was much work still to do in this regard. The law needed to respect the rights of all citizens, not simply ignore or evade the inequity of the laws.

To be fair, the very concept of a free public school education available to the children of all citizens was almost entirely new. Education had historically been a privately held privilege of the upper classes. The view of basic education being a civil right was yet to come and was a long way off. Yet it was the intention of the Nutmegers to bring this about in Ohio from the time they settled in the Western Reserve. Financing their vision would remain a difficulty in an era where the only way to provide public education was to have the community come together and build a school/town hall, passing the hat to pay for a schoolteacher. Let's face it—you had to be able to put something in the hat for your child to be able to attend the school. This was certainly a problem for Negro citizens. The first official provision made for the education of Negro children in Ohio was written into the Act of February 24, 1848:

> *By this act…the property of the negroes was to be taxed for the establishment of separate schools for themselves wherever the number of colored youth of school age numbered twenty If there were not that number the taxes on the property of the colored people were to be turned into the common fund and it was the duty of the white people to admit said black or colored children into the white schools upon the same terms as if they were white Provided no written objection be filed with the directors signed by any person having a child in such school or by any legal voter of such district.*[27]

In other words, the school taxes of Negro citizens might readily be appropriated for use in white schools while denying Negro children access to those educational structures under this provision. The law was revoked the following year and labeled as the travesty of justice that it was. Nevertheless, it is noteworthy that, as early as 1828, Hudson resident and member of the Ohio House of Representatives the Honorable Judge Van R. Humphrey voted against legislation that would have segregated Negro and mulatto children away from free public education in Ohio.[28]

In the end, the right to vote in Ohio elections was reserved specifically to white men. This provision agreed with the U.S. Constitution that defined the Negro as three-fifths of a man, thereby denying the Negro citizenship and suffrage. The code made it possible to enforce a fugitive slave law without legislating and passing one—creating a slave state without declaring one. Arguments raged regarding blacks of mixed parentage, called mulattos, and deciding the race and legal/social rights of such people became an extremely subjective thing that differed from judge to judge. Further, when someone

turned a fugitive into the law, half of any fine went to the informant, creating a strong incentive for betrayal. The word "freedom" became an academic point to many Negroes who had come with high hopes to Ohio.

Nevertheless, it is interesting to note the inconsistent attitudes regarding the status of indentures. No one had any doubt that the indenturing of free blacks was a reinstatement of their slave state. The fifteen-year indentures for blacks that the South proposed reinstating after the Civil War and that failed by a single vote in the U.S. Senate were clearly understood to be a death sentence when the life span of a slave working on a sugar plantation was seven years; however, people failed to connote the indenturing of a white man with slavery despite the fact that many owners of white indentured servants routinely starved and worked their white servants to death the last six months of their contract in order to save the money promised as a parting gift to purchase another servant, nor did they see any problem with the huge numbers of European immigrants that died digging canals or in industrial accidents. Allegedly, those men were free—and the fact that these were often coerced into selling themselves to the company store bit by bit was generally ignored.

The reasons for this double standard lie deeply embedded in the theology of the nation's Puritan forefathers, who believed in the concept of an elect class whose good works and economic blessings manifested before other men were viewed as proof of their worthiness of heaven and the fact that many early white indentured servants came to America as convict labor. England had created over two hundred capital offences to encourage those facing the gallows for stealing so much as a loaf of bread to sign over their lives as indentured labor on the hope of a chance to live. The persons who purchased these indentured convicts had a very different attitude toward these poor, friendless people than they had to their black slaves, and this attitude extended to the European immigrants that had been forced to indenture themselves to pay for their passage to America. In the Puritan mind, for God to allow a white man to be sold as an indenture, his condition was absolute proof of his status as a nonelect person worthy of hell. The indentured servant was viewed as having received a just judgment from God, and the servant's owners felt no obligation to interfere with that. On the other hand, they felt that the African, who had been given no opportunity to hear and be blessed by the gospel of Christ, could not be held personally responsible for their unblessed state. For many, this is what made the enslavement and/or indenturing of blacks iniquitous—not the institution of indentured labor or slavery itself.

Embedded in these black laws was an equally pernicious premise that the Negro could be classified as livestock. Where the humanity of the white indentured servant was recognized, the humanity of the black man or woman was not. Many worried what emancipation would mean in terms of suffrage and social circumstance. Did emancipation entitle blacks to equality with whites—as human beings? Many who campaigned for the emancipation of the Negro slave opposed such equality. They wanted to know if the freed Negro would be entitled to vote, to enter the common schools of the state and sit beside white children, to walk wherever they chose or to own property. In order to block such demands, the Ohio Constitution specifically reserved most of these privileges to white males. (White females were allowed in state schools and the private female seminaries developing throughout the state; however, white females were denied suffrage. In fact, they were given the vote long after the Negro male's privilege was secured.) Meanwhile, churches argued nonsensical things like, was the Negro a man at all? A number of ministers were heard to defend the color line by their claims that the Negro was not a descendent of Adam, and, therefore, the Negro was not covered by the sacrifice of Christ. Some went so far as to claim that

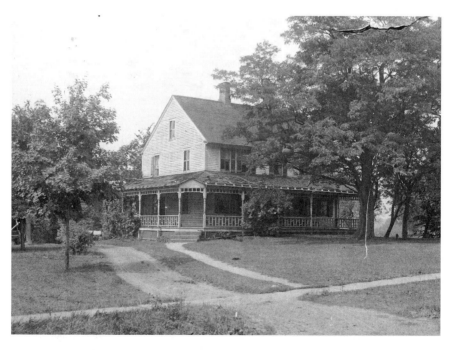

David Hudson House/Inn in 1806. *Courtesy of Hudson Library and Historical Society, photographed by William Pelster.*

there had been a Negro gardener in the Garden of Eden who had tempted Eve to sin. The question of whether the emancipation of the Negro entitled them to marry white women became a deep concern for many, though in the Western Reserve this idea was met with open laughter.[29] How, people asked, should they classify Negroes who were fair in complexion—fair enough to pass for white but weren't? For many, demonization of the Negro justified every inequality that Ohio laws supported.

In contrast, the New Englanders forming the Connecticut Land Company had insisted that slavery be permanently forbidden in the region where they were buying land, and the Keeler case firmly established the power of these transplanted Nutmegers to mount a defense against the early fugitive slave laws. The people of Hudson saw a huge mob following Keeler and his accomplice, Peter Comstock, coming south down today's State Route 91, which bisects the center of town going right past David Hudson's inn and the Owen Brown House on the north side of the village green. Owen's son, John, would have been a young man of twenty at the time Keeler was arrested, and this event cast an illuminating light on the culture in which John Brown was raised and his formative experience. Newspaper accounts say that there were so many witnesses to Keeler's crime and arrest that there wasn't space to print all the names, but it is fair to assume that this posed a huge event in the village of Hudson. Small wonder that the Keeler case turned into a grand jury affair!

It is noteworthy that Judge Tod allowed testimony from the two free black men who had been kidnapped. That is, he permitted these men to personally describe their abduction. The names of all twelve jurors—heavy hitters in the Western Reserve that included Seth Baldwin, brother of Hudson's Harvey Baldwin—are recorded in the indictment. Four judges presided: the Honorable Judge George Tod, president; Elias Lee; John H. Strong; and Thomas Card. Keeler and his accomplice, Comstock—who was the justice of the peace in Independence Township, a neighboring township of Hudson— claimed they had observed legal procedure by proving the status of Sam and Martin before a justice of the peace, i.e. Comstock;[30] however, since both Comstock and Keeler were charged and implicated in the crime, Comstock's records were ruled to be inadmissible. Although Keeler complained that his trial had been unfair because of "the rejection of testimony which ought to have been admitted; the admission of testimony which ought to have been rejected; misdirection of the judge; that the verdict of the jury was against the law; that the verdict was against evidence; that the verdict was without evidence," his appeal was denied.[31] The only real difficulty for the court came

at sentencing since there was a legitimate impediment for doing so under the existing laws of the state, so Judge Tod compromised. He allowed Keeler bail and demanded he post bond of $300, which happened to be the same amount of money Keeler and Comstock had expected to share from the profits of their crime.[32] Sam and Martin were freed immediately upon Keeler's original arrest. If Keeler had been wise, he would have left his money and run because Alfred Kelly was still successfully using the kidnap charge in defense of fugitive slaves in 1840 some twenty years later.

Unfortunately, as time went on, enforcement of the fugitive slave law tightened, and the law became more difficult to ignore. The removal of Native

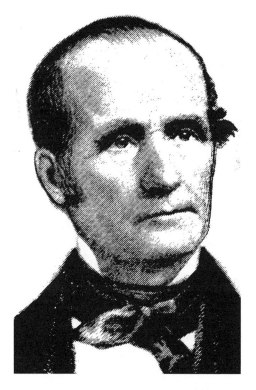

Alfred Kelly, first president of Cleveland. *Courtesy of Cleveland State University Archives.*

Americans from the Gulf region out west in the 1830s and '40s raised the specter of new cotton fields opening up that were in need of tilling.[33] Slaves in Northern states became terrified of being sold and transported there. At the same time, the building of the Ohio canal system not only opened the Ohio territory to trade with New Orleans and New York but also created "highways to liberty" that enslaved blacks in border states rushed to use.[34] Slaves fearful of being sold south traveled the canal towpaths toward freedom, and they proved a blessing to those who had no other map to guide them. Still, with so many fugitives running north and so many determined owners and professional slave catchers on the hunt for them, the drive in the Western Reserve was to aid these fugitives' escape to Canada since they could no longer shelter them in Ohio.[35] The fact that the canals had weakened Ohio's economic dependence on the South didn't hurt the situation either.[36] In short, Canada had become the true land of freedom.

Opinions regarding a solution to the national debate over slavery varied widely, and southern Ohioans jeered that those with the fewest Negro neighbors—the inhabitants of the Western Reserve—were the most likely to support immediate emancipation of the Negro. Certainly, those on the frontlines of the Ohio River had legitimate economic concerns regarding these illegal immigrants taking their laboring jobs; however, in the Western Reserve where the "Connecticut Spirit" produced highly individualist persons, they believed in government, law and justice, but legal codes imposed by a legislative body that wasn't voting their way and was violating their Christian principles were contemptible. The Nutmegers were no strangers to suing a neighbor for bushels of wheat that had been wrongfully gleaned from their fields; honoring the deed to another human soul was another matter altogether.

The Connecticut Yankee of the Western Reserve was a confident fellow, born of forbearers who had successfully defended the Union from invasion and had a strong belief in their rights and their ability to defend their rights. Generally, they were quiet and capable men but held to a religious outspokenness against all acts of wrongdoing. Years later, in the *National Baptist* of February 12, 1885, Frederick Douglass would describe this unique personality profile in his assessment of the character of Hudson's native son, John Brown, saying:

> *I have never been able to entirely explain and reconcile the heroic conduct of Captain Brown with that gentleness of temper and tenderness of heart which he always exhibited among his friends, and especially in the presence of little children…I found the highest sense of justice, a sincere love of mankind, and a total absence of selfishness.*[37]

Like Brown, most of these men were farmers, which came in handy since it took a great deal of food to operate a station on the Underground Railroad, and their women worked hard every week to have fresh cakes and pies at the ready to offer the strangers that passed through their homes.[38] They were outspoken persons of intellect and inflexible integrity who believed in the rights of the black man. While they didn't look for trouble, they weren't afraid of returning gunfire when under attack. Nevertheless, they took as their mantra the words of Deuteronomy 23:15–16, which reads "Thou shalt not deliver unto his master the servant which hath escaped unto thee: he shall dwell with thee, even among you, in that place which he shall choose in one of thy gates where it liketh him best: thou shalt not oppress him." Therefore,

it was only to be expected that they would stand up and do something about this intolerable situation.

Soon the Underground Railroad became a serious, active business. As railroad tracks were laid in parallel with the canal towpaths, a special language developed among the friends of fugitives that grew from the vocabulary of the era of the steam locomotive. In the northeastern part of the state, David Hudson and John Brown's father, Owen, were already known for harboring fugitives as early as the 1820s, and perhaps the Keeler case had something to do with that. Contemporary historians name them as the very first operators of Underground Railroad stations in the Western Reserve, and Owen Brown held the position of stationmaster in the town of Hudson. Those who harbored slaves in their homes and barns became known as "stationmasters," the shelter they offered called "stations." Those who led fugitives from one station to the next were called "conductors," and the routes from one station to the next, like a railroad line, had "spurs" and "switches" to be used as needed. One thing the friends of fugitive slaves learned early

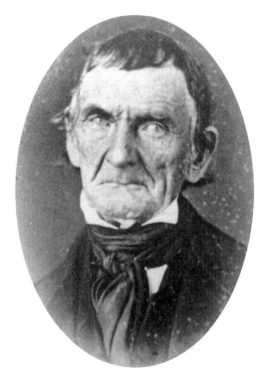

was that slave owners and slave catchers were highly successful in recapturing their escaped slaves when the fugitives traveled in a straight line.[39] Therefore, the shortest distance between the Ohio River and a steamboat to Canada was not a straight-line route at all. The network of stations developed into what Wilbur H. Siebert, a distinguished historian and Ohio State University professor born in 1866, called a "zigzag pattern" that was a great deal more difficult for pursuers to follow.[40] It was a gridwork of friends working together for justice. Siebert says that "in times of special emergency travellers would be switched off from one course

Owen Brown. *Courtesy of Hudson Library and Historical Society, photographed by William Pelster.*

to another, or taken back on their track and hidden for days or even weeks, then sent forward again."[41] This network of trails is clearly demonstrated by the Underground Railroad routes converging through the village of Hudson.

David Hudson Jr.'s diaries speak of his parents' receiving a fugitive slave and her two children in the dark of the night on January 5, 1826. The diaries go on to describe a number of other incidents involving Negroes passing through his father's home on the way north. David Jr. speaks of these incidents in a matter-of-fact manner, indicating that this was not an unusual occurrence. He even mentions a black child living in town that he says was named David for him. His father was well equipped to shield these fugitives in his large house that served as an inn and in the well house out back when caution demanded; however, in the early years, such travelers were likely sparse. Hudson's friend, Owen Brown, father of John Brown, also ran a station in Hudson—as did Owen's son, John, later. Lora Case—longtime Hudson resident, John Brown's lifelong friend and a fellow stationmaster—points out that it was rare for fugitives to come through his own station near the town of Streetsboro, though his childhood home at the Case-

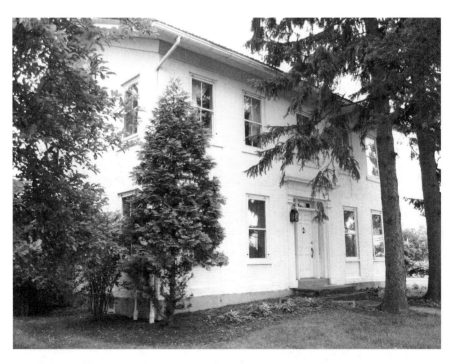

The Case-Barlow Farmhouse, the childhood home of Lora Case. *Courtesy of William Pelster, photographer.*

Barlow Farm in Hudson frequently sheltered fugitives in the woods behind the house. Siebert tells us that "a branch [of the Underground Railroad] swept northeast from Cuyahoga Falls [Ohio] to Hudson and veered to an opposite angle to Bedford and to Cleveland…Hudson was also a junction for lines from Randolph and Ravenna," making it the second most active Underground Railroad station in Summit County.[42] In fact, a number of households in Hudson opened their doors to fugitives looking for aid. In looking at the map of "Hudson's Underground Railroad Routes Through Summit County" included in James Caccamo's booklet published by the Friends of the Hudson Library, Inc., entitled *Hudson, Ohio and the Underground Railroad*, this zigzag pattern is clearly discernable. Here are shown four routes entering Hudson from the south and from the east with only two exiting to the north and the northwest.[43] The truth is that Hudson was a hub of Underground Railroad activity where, at need, fugitives could be sent weaving in six directions to evade capture. Its central location that had made it so well placed for the building of a collegiate institution made it highly suitable as a terminal. The foundational population of the town hand selected by David Hudson and fostered in the culture of the Western Reserve College produced willing hands and homes for this work in support of the freedom of the Negro.

Nevertheless, not every town of the Western Reserve was behind the effort to emancipate the slaves. Where a town supported abolitionism, it was just as likely that a neighboring town did not. A fine example of this discord is found in the story of Hudson's famous guidepost. It was in the early spring of 1835 when Colonel Artemus V. Stocking of the neighboring town of Aurora, Ohio, was approached by a town trustee to do a little work for the village. The man wanted some signposts painted and posted at the center of town where several roads converged. Stocking agreed but suggested something special for the road angling off to Hudson—which he said he would do at his own expense. The plan was acceptable to the trustee—Hudson being an abolitionist town and Aurora, at the time, being proslave. Samuel Alanson Lane, who eventually became mayor of Akron, Ohio, reports the story in his book *Fifty Years and Over of Akron and Summit County [O.]*:

> *We accordingly built a strong heavily banded and cleated board about three feet square upon which on a white back ground we painted the bust of a stalwart young negro with expanded optics broad nostrils and protruding lips his broad grin disclosing a couple of rows of ivory teeth and with the index finger of his right hand pointing in the proper direction saying: [here*

Lane draws the pointing hand] *"Dis de road to Hudson" Bolting this
board firmly to a solid oak post aided by the numerous Young America of
the neighborhood we planted it on the south angle of the road in question
We had supposed that the anti slavery people would take umbrage at it and
take measures for its summary removal but they seemed to enjoy the joke
as well as their pro slavery neighbors and the Aurora Hudson guide board
remained standing for many years eliciting many a guffaw from the passing
traveler and attaining almost a Statewide notoriety.*[44]

Obviously, the town of Aurora didn't want fugitives to stop with them! Yet
the signpost stood as testimony to the Underground Railroad activities of
the town of Hudson, Ohio.

Charles B. Storrs, the first president of the Western Reserve College,
is known to have "[inculcated] this doctrine of the new [antislavery]
conscience [in the college curriculum] as early as 1832."[45] Storrs and two
other professors, Beriah Green and Elizur Wright Jr., had been brought to
a full sense of the iniquities of America's slave-owning status through the
preaching of the abolitionist Theodore Dwight Weld. As a result, "quite a
number of the students had not only adopted extreme Abolitionist views
but engaged earnestly in the discussion of the question in the class room in
fraternity meetings and in public lectures both in Hudson and elsewhere."[46]
Three antislavery societies developed in town, and the young men of the
college were ready in the summer of 1858 when slave catcher Anderson
Jennings traveled the Western Reserve from Sandusky to Painesville in the
company of state's deputy marshal A.P. Dayton of the Northern District
of Ohio. It is doubtful that these men held so much as a warrant for their
mission, but they found a number of northern Ohio towns swift to show
them the door.

*On Monday night of Commencement week August 23, 1858 just as
President Hitchcock of Western Reserve College had closed his address
to the College societies the attempt* [to kidnap a fugitive slave] *was
renewed. The fire bell was rung and the students rushed to the scene of
action and again their would be captors hurried off without their prey.*[47]

Newspapers across the north coast informed readers regularly of such
attempts and the happy arrival in Canada of fugitives whom many of
northern Ohio's citizens had aided in their quest for the North Star.

CHAPTER 3

THE AFRICAN COLONIZATION SCHEME AND THE WESTERN RESERVE COLLEGE

When Beriah Green, professor of sacred literature, took the pulpit of the Western Reserve College Chapel in the fall of 1832, his words fell on both receptive and nonreceptive ears. Telling a bunch of Puritans that they could not support the efforts of the American Colonization Society to send emancipated slaves back to Africa—a cause dear to their missionary-orientated hearts—and call themselves Christians was hot stuff. The people of the Western Reserve prided themselves upon their Christian character! Green would apologize later for the disruption to collegiate life that he caused the Western Reserve College and the town of Hudson, whose hopes for the college had been so high. Yet there is no denying that his words struck a chord then, as they do now:

> It is not for me, my brethren, to control the parties, which you may have formed or dictate the politics, to which you are partial. With your parties or your politics, as such, I have nothing to do in this discourse. But when the one or the other leads you to occupy ground, which your Lord and mine forbids you to hold, then as a watchman, whose office requires him to care for your safety, it is my duty to warn you of impending disaster...You are in danger of cherishing a prejudice deadly to your own peace and hostile to the dearest interests of a large mass of oppressed humanity. Be assured you cannot do so with innocence or impunity. 'Whether you will hear or whether you will forbear' it is mine to warn you that you cannot do so without staining your character and forfeiting the smiles of heaven.[48]

Western Reserve College
Chapel. *Courtesy of William Pelster,
photographer.*

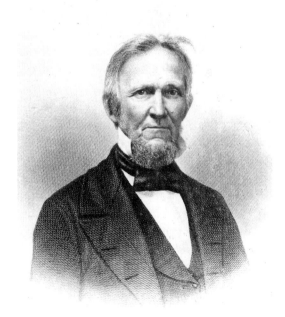

Beriah Green, professor of sacred
literature. *Courtesy of Case-Western
Reserve University Archives.*

Surprisingly enough, the question of the elimination of slavery in the newly formed United States of America was one that had been on the table from the very beginning. Thomas Jefferson's first draft of the Declaration of Independence contained an extremely forthright clause outlining the American Negro's cause for complaint against King George III and calling for their inclusion in the document under the "All men are created equal" principle. This, and other passages containing insulting language directed toward the monarch, was excised in pursuit of a dignified statement of the colonists' case against England. Representatives of Southern states opposed the provision on the grounds that emancipation would destroy their economy. Jefferson acknowledged that emancipating the Negro would have a devastating effect on the rest of the nation, as four million unskilled laborers were released into the population with nowhere to go and no means of self-support. Further, the thought of those four million people demanding the right to vote and upsetting the white man's balance of power in America was off-putting to both the North and to the South. Naturally, including white women to the privilege of suffrage to balance things out failed to occur to any of these men. Of course, Jefferson had personal reasons for his stance regarding slavery, being the father of several mixed-race children himself, yet his bitterness at being required to expunge the passage did not stop him from keeping a copy of the original document and publishing it later in his autobiography. Instead, he complained that those who owned the fewest slaves and had the most to do with transporting them to American soil had done the most to block the passage of this excellent provision. The problems resulting from ignoring and denying the rights of America's Negro population would only grow bigger.

Despite the hostile laws put in place in the state of Ohio to discourage Negro immigrations, a rapidly increasing Negro population alarmed white citizens. The state lay in the natural pathway of escape to Canada. Slave owners of tender heart were actually founding colonies of emancipated slaves by buying and holding land in Ohio and then sending their freed slaves to live there; however, as Jefferson warned, an established plan for finding a place for freed Negroes in American society and in the workforce was essential to emancipation. There was little reason to free them if they had nowhere to go and no means of support. The economic/social ramifications of these vagrants flooding into a single state of the Union, having no means of self-support, had the potential of spelling financial ruin for Ohio. This danger produced two effects in Ohio settlers. Some demanded more effective legislation to discourage such migrations, and some agitated for immediate

emancipation. It was then that a proposal was submitted to Congress on December 18, 1816, to formulate an organization—the American Colonization Society—whose purpose was to purchase land of equal value in Africa and convey emancipated blacks back home. This solution pleased a lot of people for a number of reasons.

Slave owners liked the proposal because emancipated slaves communicating the principles of freedom to their slaves caused ill will among the enslaved and raised the specter of revolt. The response of slave states to this problem had been to make it illegal for emancipated slaves to live in their home state, necessitating their removal to slave-free states that didn't want them either. This policy also served as a deterrent to freedom among the enslaved who managed to earn money on the side and purchase their freedom, as a significant percentage of enslaved Africans did, because it meant that they must leave their families behind and go forth into the great unknown. Over time, a number of churches came to like the idea of colonization because they envisioned teaching emancipated blacks to read the Bible, giving them a little money and aiding their passage back to Africa as a missionary endeavor. This, they believed, would result in the conversion of the Dark Continent to Protestant Christianity, alleviating the Negro race's segregation from the gospel of Christ. Further, the scheme had the benefit of removing the Negro race from American soil altogether, which pleased the people of the North who saw themselves becoming a dumping ground for elderly emancipated slaves who would end up in need of public support. The North saw the slaves, as Jefferson had, as victims of a crime. This was fine as far as it went, but the upshot of it all was that they had convinced themselves that it was the right thing to do—to return the kidnapped victims of King George III's slave acquisition project home to Africa while establishing the guiltlessness of any current slave owners in the whole affair. The trouble, of course, was that it failed to take into consideration that most of the slaves no longer spoke their native tongue, were unable to say where their ancestors came from and had no wish to be exiled from the only home they knew. The fact that a number of Negroes had also fought in the Revolutionary War—for the very freedom that was now denied them—was embarrassing.

The proponents of the Colonization project insisted that their proposal was being put forward entirely on behalf of the Negro, but a shortened list of their reasons says otherwise. Green's fourth sermon that quotes Professor Hough's speech before the Vermont Colonization Society gives a just slice of these arguments: "If we allow our colored population to remain among us, they will remain the same degraded, unenlightened,

Elizur Wright Jr. *Courtesy of Case-Western Reserve University Archives.*

unprincipled and abandoned race, that [they] are [now] found, equally worthless, and noxious in themselves [and] equally a nuisance to the public."[49] This sounds just ghastly to the modern reader, but the condition of blacks arriving in Ohio—dirty, uneducated, unskilled and economically dependent—made them alarming objects to those with neat, ordered, hard-earned lives. Further, their presence violated that sense of personal ownership of the Western Reserve the Nutmegers held dear. The solution of purchasing land of equal value in Africa with which to compensate these freed slaves and to aid their transportation thereto rose out of the arguments they had used with Congress to secure the lands of the Western Reserve. They wished to see the Negro given compensation, land equal in value to the land they themselves had received—just not their land. But the thing that made the American Colonization Society's position so revolting was the way that they lumped all guilt for slavery onto King George III while excusing current slave owners from blame.

In addition, Elizur Wright Jr., the Western Reserve College's professor of mathematics and natural philosophy, pointed out a critical flaw in the

entire plan. In his short book *The Sin of Slavery, and Its Remedy; Containing Some Reflections on the Moral Influence of African Colonization*, published in 1833, he states, "Southern Colonizationists cannot be serious in proposing the removal of the whole colored population for they well know that this cannot be effected without the substitution of white laborers, a problem evidently more difficult than the removal of the blacks, and yet their plan takes no cognizance of any replacement."[50]

Here Wright nails a crucial point. Where would the nation find an acceptable labor force to substitute for slave labor? What they were suggesting did, in fact, circumvent the issue of what would happen to the slaves if they were freed—i.e. they would no longer be a problem in America. What then? The fact that the American Colonization Society had its roots in the southern United States should have been a clue as to its dishonest intent, and a number of people in Hudson stopped giving contributions to the American Colonization Society when they realized this. Wright supposes that the colonization scheme is simply a ploy to placate the North while intending to do nothing substantial at all to free their slaves, but Wright was wrong, and he should have known it. The North had already transitioned

The Elizur Wright Jr. House. *Courtesy of Hudson Library and Historical Society, photographed by William Pelster.*

almost completely to immigrant labor, and already the movement to recruit more Europeans was a glimmer in Northern industrialists' eyes.

By 1860, with the emancipation of most of Europe's serf population, the labor force America was looking for to replace the Negro slave became available. Already half of Ireland had immigrated to America, followed by a nearly equal number of Germans due to harsh economics at home. The only reason the South had failed to follow the North's lead in this matter is that the immigrants flooding into America were flowing west through Missouri, bypassing the cotton and sugar fields of the South to get to the free land opening up in the West. Nevertheless, if everything had gone smoothly, the wave of European immigrants from the 1850s to the 1920s would have seamlessly replaced black labor in America. Not that this really bothered American industrial leaders in the North all that much because slavery had never really been about color. When the early colonists wrote back to England, expressing the need for laborers, England had emptied the poorhouses, the jails, the orphanages and pinched people off the streets—all of whom were white. Certainly, color was one factor used to identify friendless poor people who could be exploited. Ethnicity was another, and the keen jealous eyes of the privileged classes were good at identifying the exploitable. The Irish, the Welsh and the Scotch found themselves up for grabs as well because the underlying purpose of slavery was to secure minimum-cost-to-the employer labor any way it could.[51] The exploiters really didn't care if slaves were black, red, white or yellow. In fact, by 1860, a good portion of the field laborers in the Caribbean working side by side with Negro slaves under comparable conditions were Chinese![52]

Henry Ward Beecher's speech before the Anti-Slavery Society delivered in New York on January 14, 1855, makes plain the philosophies of labor that divided the North and the South. The South, he said, encouraged indolence when they told their slaves that they would work all their lives and earn nothing, but in return would be cared for from the cradle to the grave. The North, he said, was different. Referring to the massive European immigrant population arriving on American shores, he promised that "the poor wretches whom foreign slavery has crippled and cast upon us" would be expected to work.[53] The Northern philosophy of labor was that their laborers would "have the fullest chance, and then [they will also] take the whole result of [any] indolence…The northern system intend[ed] to punish those who will not work."[54] In other words, the North had no intention of providing for a person's old age like the slave owners of the South did when the wages paid by the North if prudently managed should take care of these

immigrants through their old age—a philosophy born of the Protestant work ethic. Further, all those immigrants competing for laboring jobs against free blacks kept minimum wage down for the foreigner and for the freed black more effectively than ridding the country of Negroes all together. In short, the North had found a more subtle way to beat workers and drive them to work than to use an actual whip, and it was going to save employers money and responsibility. It was these employers' contention that the wages they offered their laborers were sufficient to provide for those workers' old age if they lived modestly and saved. This, of course, was a farce! The wages offered paid only for food, occasional clothing and maybe a bed—but no medical care—for one man without a family on a day-to-day basis. If he was sick, there was no pay; if he was maimed or injured, there would be no compensation; if he had a wife and children, that was his problem.

Needless to say, it is not surprising that most emancipated slaves not only turned a deaf ear to the blandishments of the American Colonization Society, but they also began organizing to oppose this movement. A primary complaint was cruelty. Reports of early colonists perishing on shipboard before ever setting foot in Liberia, finding the place ill equipped to receive them and dying due to disease-bearing insects were hardly inviting. The fact that Liberia was surrounded by slave-trading nations was no thrill either, and the presence of a British man-of-war in the harbor was not all that reassuring. Negroes meeting in convention in Ohio declared "that Ohio was their native land and that here they would live and fight for their rights."[55] They also resented the propaganda put out by the American Colonization Society concerning their race's depraved character as it was only increasing the race hatred leveled against them from all sides. Though, to be fair, Ohio was bearing a disproportionate share of economic burden for what was now a national disgrace.

In addition, both the United States government and the American Colonization Society were finding it difficult to fund the Negro deportation project. By this time, the expanding Negro population presented an insurmountable economic barrier to African colonization because when slave importation became illegal, slave breeding became the practice. The price of transporting America's Negro population back to Africa was enough to sink the country's economic ship. So another proposal was put forward. The American Colonization Society had noted the United States' burgeoning demand for coffee; however, supplies were severely limited, and they felt that an additional tariff placed on the precious beans for two years would supply needed funds for the transportation to Africa of all of Ohio's Negroes, the erection of homes

for them in Liberia and the planting of crops—hopefully coffee.[56] In other words, the organization was proposing the transporting of emancipated slaves to Africa for the purpose of working coffee plantations that would in turn keep the American nation well supplied with the wonderful beans and likely for a reduced price, as America had helped to father the venture. To them, the fact that the workers would be freed men and women owning their own businesses essentially made all the difference between their scheme and King George III's sugar plantations. They weren't fooling everyone, although many conservative Christians were taken in.

Famed British journalist/economist/novelist Harriet Martineau, touring America in the 1830s, summed it up this way: "Those of the Dusky race who were too clever and those who were too stupid, to be safe and useful at home, were to be exported; and slave-owners who had scruples about holding man as property might by sending their slaves away over the sea, release their consciences, without annoying their neighbors."[57]

No wonder the South hated Harriet almost as much as they hated Harriet Beecher Stowe! Harriet Martineau would eventually come to be known as the first female sociologist for her observations of society in America, her scathing assessment of Britain's colonial policies in Ireland and in India and her shrewd analysis of the effects of Britain's economic policies upon the common man and woman. She had come to tour the American experiment in Enlightenment and had her finger on the pulse of the situation. Martineau was particularly blessed in her opportunities to observe American society—well beyond the citizens of the Western Reserve—though, indeed, she traveled Ohio, and her comments on the Black Laws of Cincinnati are worth noting. Southern political leaders gave her a guided tour of the South in the hopes of a favorable internationally published report regarding the labor practices of the Southern United States. In a private conversation with President James Madison, who had been elected as president of the American Colonization Society, he expressed to Martineau his frustrations on the topic of slavery. He complained of the practice of slave breeding where every girl above fifteen years of age was expected to become a mother; he complained of free states that refused to receive emancipated slaves; he complained that Canada disagreed with them and that Haiti refused to take them either. According to Madison, Africa had become the American Negroes' only refuge, though he admitted that when forced to sell some of his own slaves the week prior to his conversation with Harriet, he had been sensitive to their wishes and had not emancipated them for shipment to Africa. He said that he had been forced to sell, by the way, because one-third of his slaves

were younger than five years of age, and his land could no longer provide the food needed to support so many. Then he pointed to the dissatisfying state of Liberia itself, blaming the residents—emancipated blacks—that were expending more energy trading with neighboring nations for luxuries and failing to raise food to provide for newcomers to the colony.[58] But Harriet was undeceived by his show of sensitivity, connoting the institution of slavery in America closely with the class prejudices so rampant in Britain. Harriet reports that a Southern gentleman told her the truth, saying that there were

> little…known…reasons off the new laws by which emancipation was made so difficult…the very general connection of white gentlemen with their female slaves introduced a mulatto race whose numbers would become dangerous if the affections of their white parents were permitted to render them free The liberty of emancipating them was therefore abolished while that of selling them remained.[59]

At last, the truth! Further, Harriet was made aware firsthand regarding the attempts in America to "reduce foreigners to slavery"—such as European immigrants—as well as when poor Irish were also claimed by slave catchers, requiring legal aid from abolitionists to prove their free status.[60] Nevertheless, she did make a powerful mitigating observation regarding the American Colonization Society itself when she said "the Colonization Society originated Abolitionism. It acted in two ways. It exasperated the free blacks by the prospect of exile, and it engaged the attention of those who hated slavery."[61] This was exactly so, and Harriet, who had already met William Lloyd Garrison in Boston, forming a lifelong friendship with this man, would know.

Meanwhile, in Ohio, a different movement began to take shape. It differed only slightly from the American Colonization Society's program. On the other hand, it had the approbation of some heavy hitters like George Washington, Thomas Jefferson and Patrick Henry.[62] In Hudson, therefore, an Anti-Slavery Society was formed. No one needed to say much more to win the favor of David Hudson, son of a Revolutionary War veteran, than to whisper the name of General Washington. Hudson had been forty years old when he came to found the village of Hudson; he had built his little Eden in the wilderness; he had defended the faith; he had shielded fugitives at his door; and he had brought higher education to the people of the Western Reserve and their sons, including some few black men who received higher education at the Western Reserve College. He

was getting old. The rhetoric must have appealed to the aging Christian warrior, and so the town and the college busied themselves, writing a constitution for their chapter of the Anti-Slavery Society. David Hudson Jr.'s diaries speak of meetings at the college, setting up in type (he worked as a printer) circulars for the local society and the various charitable events like concerts and contributions he made to the school for black children in Pittsburgh.[63] Nevertheless, the differences between the Anti-Slavery Society and the American Colonization Society were relatively few. Their purpose was to work to prevent the spread of slavery and to encourage the South to emancipate their slaves by sending them to Africa *if they desired to go*. This was the crucial difference between the Anti-Slavery Society and the American Colonization Society—it took into consideration the willing consent of blacks. As a concession to the South, the Anti-Slavery Society discouraged meddling with out-of-state slaves and their owners. Further, the Anti-Slavery Society emphasized the apostle Paul's words to Philemon regarding the escaped slave Onesimus as providing scriptural basis for the support of slavery in a Christian society.[64] All of this gave the movement a nice holy touch, but as Beriah Green was telling the community of the Western Reserve College, it was nothing of the kind. No matter how clean the cup looked on the outside, it was dirty inside.

Unfortunately, that wasn't always easy to see. Local newspapers were filled with arguments over the slavery issue. The American Colonization Society appeared to offer hope for the Negro that was badly needed, but white citizens were in need of solutions too—solutions to the economic, social and political facets of the problem that affected them personally. The question of whether free blacks were citizens was a hot topic. Editorial columns raged that citizenship was only for the white man, and even if it was not, citizenship did not automatically confer suffrage upon the black man when the daughters of white citizens had yet to achieve suffrage. Reprinted articles from Southern newspapers preached gradual and safe emancipation, if only because of the burgeoning black population. Like President Madison, many owners burdened with a huge infantine Negro population were willing to divorce themselves from responsibility to a portion of their slaves' offspring by sending them to Africa—a new children's crusade. The concern was that "men who plant trees for the shade of future generations, ought to consider that deeper shades may at least recline beneath them."[65] Others worried that they might be taxed to fund the deportation of Negroes to Africa. Some newspaper subscribers complained that there was entirely too much attention given in print to the subject, but the American Colonization Society was always

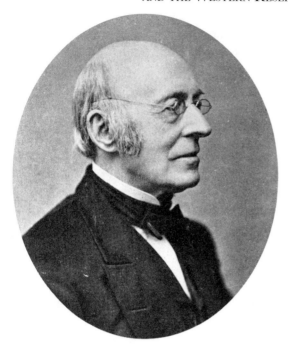

William Lloyd Garrison.
Courtesy of the Library of Congress.

swift to point out that they were offering a moral solution to a horrendous problem, promising proponents a "halo of moral glory."[66] No wonder so many good-hearted people fell for the scheme, what with letters telling of repentant slave owners availing themselves of this option and assurances from the Colony of Liberia that all was well—that emancipated residents were both happy, fulfilled and grateful to the American Colonization Society for their efforts on their behalf.

Then, a copy of William Lloyd Garrison's newspaper the *Liberator* fell into the hands of Beriah Green and Elizur Wright Jr., professors at the Western Reserve College in Hudson. The paper blended scripture with the strains of liberty so dear to the hearts of the transplanted Nutmegers, adding a dash of Enlightenment theorems. The *Liberator* threw all their most cherished beliefs regarding liberty and equality in their faces and labeled them a farce. Garrison called the American people to acknowledge the wronged immortal souls of the Negroes that had been mutilated by abuse and denied "the light of the gospel."[67] This appeal to faith would do exactly what Harriet Martineau said it would do; it roused the attention of honest-hearted men and women in defense of the captive slave. Garrison tells the public forcefully that "we have all committed the act of oppression, directly or indirectly; there

is innocent blood upon our garments, there is stolen property in our houses; and everyone of us has an account to settle with the present generation of blacks."[68] He warned that he would not let the matter rest, but he would pursue justice for these people until it was achieved. The first issue of this paper, by the way, was printed on faith—Garrison had no paid subscribers at the time. He soon accumulated subscribers, and the heart of the Western Reserve reverberated at a pitch that would shatter relationships.

The seed that was planted grew in the hearts of three influential men from the Western Reserve College: President Charles B. Storrs; Beriah Green, professor of sacred literature; and Elizur Wright Jr., professor of mathematics and natural philosophy. Everyone at the college supported emancipation in one way or another, but Beriah Green, who possessed the privilege of use of the college chapel's pulpit, saw it as his duty to educate his students to the iniquities of the colonization scheme. So in the fall of 1832, he climbed up into the pulpit and preached emancipation—immediate emancipation—whatever it took.

Green's first sermon attacked the tendency to apologize for current slaveholders as though they were also victims of a crime, holding them guiltless of the sin of enslaving fellow human beings.[69] Further, he questioned the American Colonization Society's ability to judge the character and potential of the Negro as citizens in American society when colonizationists freely admitted their implacable prejudice regarding those of the Negro race. Green went on to compare it to the prejudice of the first Jewish Christians for Gentile converts.[70] Then he touched upon the communion table itself, pointing out that Christians must all approach that table as equals to win the favor of God. Finally, he debunked the idea of Christians comfortably turning their heads in worship of expediency rather than reach out the right hand of Christian fellowship to all of their fellow human beings, whatever their color.[71] Soon, the word around town and in the local papers was that Green had desecrated the chapel pulpit, using it as a platform for political rhetoric and philosophy—a view he immediately challenged.[72]

In Green's second sermon he quoted from the book of Matthew, chapter five and verse thirty-five saying, "That upon you may come all the righteous blood, shed upon the earth, from the blood of righteous Abel, unto the blood of Zacharias [son] of Barachias, whom ye slew [between] the temple and the altar."[73] Green had the wind up now, determined to bring the guilt home to each and every member of his audience. He spoke about punishment due for accumulated guilt; he spoke about "the spirit and habits of their ancestors" in withering tones; and he spoke not of gentle spiritual

chastisement but of vengeance and judgment from God.[74] His point was that the actions of many generations had accumulated a guilty sin in their hearts that they shared equally with the originators of slavery in America. Green saw their racial prejudice that mounted a barrier to blacks sitting at Christ's table beside them as equals as the primary sin. "And so the cup goes down. Generation after generation drink and die," Green says, likening the slaveholding population of America and the two-faced Christians who supported gradual emancipation to the dysfunctional family of a hereditary drunkard where the pattern of abuse and addiction repeats itself.[75] Sneering at the helpless efforts at redress put forth by his fellow Christians in the face of this enormous injustice, his third famous sermon condemns the selfish motivations of those who would advocate colonization.[76] These, Green says, claimed that the character of the Negro evoked insurmountable obstacles to their acceptance in society, but Green sees this to be a syllogism—a subtle and deceptive reasoning. How, he asks, quoting John 4:10, can people who admit their prejudice justly judge their brother when "with one hand, they, with seeming reverence, [open] the sacred volume, [and] with the other, they [rivet] a yoke upon their brother's neck?"[77] It was hypocrisy, and Green called it.

Soon most of the faculty of the Western Reserve College became advocates of the abolition stance. Students resigned from the Anti-Slavery Society. Garrison's *Liberator* had convinced Beriah Green, Elizur Wright Jr. and President Charles B. Storrs that gradual emancipation was not enough. Green's sermons released a tidal wave of agitation in the Hudson community. Students were spending more time going about giving abolitionist lectures and spending less time at their studies. A sense of urgency gripped the little town just as it was gripping the rest of the nation. Things were heating up: many small towns of the Western Reserve found themselves in conflict with their neighbors. Western Reserve College student Isaac Bigelow lectured in Hudson and in neighboring towns only to find himself surrounded one night by a mob promising to "tar and feather him when he came out."[78] Samuel Alanson Lane, who eventually became one of the town of Akron's mayors, was part of the liquored mob threatening Bigelow that night.[79] Meanwhile, the aim of the college's board of trustees was to maintain liberal neutrality in an era leading up to war. Parents had always appreciated the secure environment to which they were sending their sons. The trustees of the college had become settled, comfortable men who had invested a lot of time, money and effort to make the jewel of their old age, the Western Reserve College, a reality. The time for emancipation was now, but the rest

The William Hanford/Beriah Green House. *Courtesy of William Pelster, photographer.*

of the college elders thought otherwise—this included Elizur Jr.'s father, who was on the board of trustees. President Storrs, Elizur Wright Jr. and Beriah Green would leave the college "on account of the strong opposition of the trustees on this account, and because they allowed the slavery question to be discussed by the students."[80] A clear generational divide was seen, and as usual, idealism was championed by youth.

Nevertheless, it is all too easy to blame Green for causing a ruckus just because the nation had come to the boiling point regarding slaves and slaveholders. The little Congregational church where a youthful John Brown had been received as a member in 1816 was having growing pains, and his father, Owen, was in the thick of it. The Presbyterians and the Congregationalists who had met in worshipful unison together since the founding of the village were having their differences about slavery and gradual emancipation versus immediate emancipation. Hudson's Congregational Church records from 1836 contain a resolution regarding the congregation's stance on slavery. The document complained that slavery violated the Golden Rule, that slaveholders were sinners "living in

First Congregational Church marker. *Courtesy of William Pelster, photographer.*

the known commission of [a] crime," that it was their duty as Christians to speak in defense of the captive slave and that their church pulpit would be closed to all clergy who failed in their duty to speak out against slavery and slaveholders.[81] The church followed this up with a prompt request to sever relations with the Presbytery of Portage County, meaning the Presbyterians.[82] The era of the Comeouters—those who refused to share communion with individuals and churches that defended slavery—was upon them.

CHAPTER 4

THE RISE OF ABOLITIONISM

When the Reverend Elijah P. Lovejoy was forced out of St. Louis, Missouri, because he had printed a full account of the burning at the stake of a Negro man named Francis J. McIntosh by the gentlemen of St. Louis, he knew he was risking his life to continue printing his abolitionist newspaper. He had already had three printing presses destroyed. Nevertheless, he determinably moved across the river with the intention of setting up his printing press in the slave-free state of Illinois. A committee of gentlemen representing the business interests of Alton, Illinois—deeply tied up in trade with the South—called on him to close up shop there as well. Under the guise of civilized negotiation, they demanded Lovejoy surrender his principles, stop publishing his paper, the *Alton Observer*, and leave their town. Lovejoy clearly understood his peril, having been mobbed in Missouri three times only to find his young wife cowering in the attic, but he stood firm—until a mob delivered five bullets into his body and the thirty-two year old husband and father lay on his face, dead, his printing press that had been supplied by the Ohio Anti-Slavery Society thrown into the river. The intense proslavery sentiment in Alton made it impossible to bring the criminals responsible for Lovejoy's murder to justice.[83]

At the same time, from the heart of the Western Reserve town of Hudson, a strong quiet voice rose in response to Lovejoy's martyrdom that would ring out through history in defense of civil rights and freedom of the press. It was at a prayer meeting on a Thursday afternoon that the members of Hudson's

Appleton's Elijah Parish Lovejoy. *Courtesy of James Grant Wilson and John Fiske's* Appleton's Cyclopædia of American Biography. *Vol. 4.*

Congregational church were informed of the death of Elijah Lovejoy and of the destruction of his printing press. In fact, the event had formed the reason for the meeting. At this time, John Brown's childhood friend, Lora Case said, "There was…a strong prejudice in the church and throughout the state against the anti-slavery movement."[84] Certainly this would be true in the southern portion of the state where a number of people's livelihoods depended on good relationships with slave owners and trade with New Orleans. Wise elder heads sensed the potential for violence and disorderly conduct that swept in the wake of abolitionist rhetoric. More churches were closing their doors to rabble-rousing abolitionists, denying them use of their pulpits on the grounds that politics and violence were contrary to the worshipful purposes of religion. Even the Quakers of southern Ohio agreed with this stance, shutting their doors in the 1840s to abolitionists and warning members against participation in Underground Railroad activities.[85] Nevertheless, Owen Brown rose to pray upon hearing the news, and it is to be noted that John Brown's father spoke with a strong stutter unless he was singing or praying; prayer was his chosen form of oratory. His prayer was earnest, asking God for a decision as to what they as Christians should

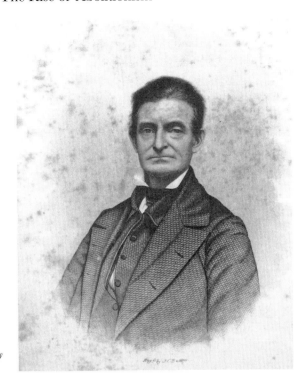

John Brown lithograph.
Courtesy of Hudson Library and Historical Society, photographed by William Pelster.

do in response to Lovejoy's murder. Case said that "it seemed by [Owen's] expressions as we listened to his prayer that he felt as though the Judge of all the earth was at the door of his heart."[86] Under the circumstances, and in that place where so many of the church members were also business leaders in sympathy with order and economics, it was a brave thing to do, but the founders of the Western Reserve were men of courage. After the prayer, Owen's son, John, stood and spoke in a calm emphatic voice, saying, "I pledge myself with God's help that I will devote my increasing hostility towards slavery."[87] There was no ranting, no shouting, just a solemn promise John Brown meant from the core of his heart.

The young John Brown was no stranger to the inequities of slave-holding America. Like his father, he was a confirmed abolitionist, and there was a growing tension in the little town of Hudson between those of the abolitionist persuasion and those who still held to the ideals of the American Colonization Society; however, the younger David Hudson that John Brown knew as a child was also enamored with the abolitionist cause. In September 1831, when news of the Nat Turner rebellion reached Hudson, Elizur

Wright, who had attended school with John Brown in Tallmadge, Ohio, met Squire David Hudson at midmorning as he issued forth from his post office with a newspaper in hand. Hudson was extremely excited by what he was reading, and as Wright came within earshot, he heard the "Old Calvinist" exclaiming, "Thank God for that. I am glad of it. Thank God they have risen at last."[88] Hudson was the son of a Revolutionary War veteran and would naturally connote the Negro battle for emancipation with the colonists' fight for freedom from England. To such men, the fact that the Negro slave was unwilling to stand up and fight for their freedom was inconceivable. They just didn't understand it. For this very reason, the right to bear arms had been written into law in America, and it was a right the men of the Western Reserve held dear.

Nevertheless, Hudson's response to the Nat Turner rebellion may have seemed contradictory to the average Hudson resident who knew David Hudson to have been a staunch advocate of the American Colonization Society, but time marched on and people's attitudes and beliefs adjusted with circumstances. It is easy to forget that Hudson, along with Owen Brown, was known also to be the first to harbor escaping slaves in the northeastern quarter of the state and never turned a fugitive away from his home, whatever his political view might be. By now the older man just didn't see that he would have to choose between the American colonization scheme and the abolitionists' message—he likely thought he could do both. Hudson, like many others, would become divided over the issue because his own life's work was on the line with the well-being of the Western Reserve College.

The thing is that the abolitionist cause had come into disrepute due to its disruptive social and economic potential. Lies had been put about regarding the abolitionists' beliefs and their methods, then there was the fear that the abolitionists' violent rhetoric would only make matters worse for the slaves of the South, but they were wrong. As Harriet Martineau arrived in New York City, the abolition riots had just taken place, and the ship captain was doubtful of allowing her to land because an abolitionist would not last long in that place. A lady companion assured him that Harriet, an abolitionist in principle, had come to observe American society, not to teach;[89] however, Harriet did find a land on the verge of chaos with riots in New York, bank riots in Baltimore, Lynch Law raising its ugly head in Vicksburg, the post office in Charleston broken into for the purpose of burning abolitionists' mail and the horror of a black man burned alive by the gentlemen of St. Louis. No wonder conservative family men were keeping quiet. The fact that these mobs were peopled by educated gentlemen—clergy and business

leaders—she found to be extraordinary because in England mobs operated quite differently. In England, paupers rose against the gentry and the upper class to protest injustice. These mobs, she found, were formed of cultured well-to-do men who had decided that the laws of the land were insufficient discouragement to the abolitionist cause.[90] But that didn't make these mobs innocent or less dangerous; the potential for the flashover use of deadly force was enormous, as Lovejoy's murder attests. Further, the blame for the violence was falling on the abolitionists themselves rather than on the perpetrators, giving abolitionists a bad public image. Martineau found that the United States Senate had made an informal rule to violate the abolitionists' right to petition Congress by laying aside any such correspondence on a side table to be left unread, and a movement was afoot to deny the use of postal facilities to those seeking to distribute abolitionist literature.[91] The social blackmails were huge. Harriet says that abolitionists "found their brothers dismissed from their pastoral charges, their sons dismissed from colleges, their friends excluded from professorships, [and] themselves disbarred from literary and social privileges."[92] It was getting hard to find a hall to rent for a meeting because abolitionist speeches were subject to assault.

The pressures mounting in Ohio and in the Western Reserve were similar. In 1834, the students of the Lane (Theological) Seminary of Cincinnati held a serious three-day discussion regarding the issue of emancipation, forming an abolition society at the college. The college faculty warned the young men that they must cease this activity or be dismissed.[93] It was about this time that abolitionist Arthur Tappan offered the Western Reserve College a large sum of money for their endowment; however, there was a catch. Tappan knew how influential the college had become, and he wanted them to "be liberal on the anti-slavery question, i.e. liberal to the anti-slavery element, and admit females on equal terms with males, and appoint Charles Finney as one of its professors."[94] The offer was coupled by an inquiry from the students of the Lane Academy, who had been suspended from school and wanted to come to Hudson's Western Reserve College, where they hoped to find a more liberal atmosphere. The trustees of the college, though the college always admitted black men "to the privileges of the Institution," refused both of the more progressive propositions.[95] Meanwhile, John Brown's father, Owen, was dissatisfied as to how Professor Green had been treated over his four sermons in the college chapel. He, therefore, removed his patronage from the Western Reserve College to organize a new collegiate institution in Hudson that was later moved to Oberlin, Ohio, and organized along Tappan's guidelines. The Lane seminarians followed the Tappan money to

Oberlin College.[96] In addition, Harriet Martineau issued an international appeal for funds for the new abolitionist college that was greatly in need of sponsors.[97] The problem was that the Western Reserve was unable to sustain two colleges, and suspicious fires in New York would severely limit Tappan's continued support of Oberlin College.

In Hudson, Arthur Tappan's gift to Oberlin College tipped off a small war of its own. It was bad enough that Tappan's money had gone elsewhere, but when a prominent Hudson settler like Heman Oviatt gave $10,000 to the new rival college, the Congregational Church of Hudson and its minister were incensed. A public trial ensued. "The church brought Dawes, one of their members who was an ardent Abolitionist, to trial on the charge of false representation to Oviatt, thereby inducing him to make this gift," said Lora Case.[98] The church enlisted the aid of a minister by the name of Skeldon to make the charge stick; Dawes used Oberlin College's professor of theology, Charles Grandison Finney, to defend himself. Of course, it was no business of the church to decide where Heman Oviatt invested his money—he certainly hadn't violated any laws of the church or of the state. So the Congregational Church lost its action, but from then on Finney

The William Dawes House. *Courtesy of William Pelster, photographer.*

and any other Oberlin-inclined minister were barred from the Hudson Congregational Church's pulpit. Worshiping together became impossible, and so Owen Brown started the Free (Anti-Slavery) Congregational Church of Hudson on the southeast corner of the village green. It was getting hard just to cross the center of town on a Sunday as the two factions passed each other going in opposite directions. To the modern eye, the dissention may seem ridiculous because the new church's covenants don't appear very different from the ones that the original Congregational Church had sent to the Presbyterians when they ceased their mutual fellowship. Further, as disgruntled as Owen Brown was over the treatment meted out to Beriah Green over his four sermons, nothing really happened to disturb the peace of Hudson until the Tappan money split the town. The critical clause from the Records of the Free Congregational Church of Hudson organized on October 7, 1842, reads like this:

> *Article 13 Whereas a great portion of the church of nearly all denominations, are withholding their testimony & influence against the sin of slavery & oppression & whereas we believe the continuance vs. Abolition of slavery depends in a great measure upon a right procedure on the part of Christ's representatives on earth, therefore we in assuming to be witnesses for Christ & Cooperators with him in the work of removing all sin from the face of all the earth, establish it as a rule in our church to receive no one into our communion who is a slave holder or an advocate of slavery nor will we invite a slave holding minister or one who advocates the system of slavery to preach or officiate in our pulpit.* [99]

Obviously, the real argument was about the money and the new competing college. The Western Reserve College had become central to the economics of the village, many people housing college students in their homes, and so anything that distressed the economic health of the college distressed many of the town's inhabitants.

In the early spring of 1843, the little "Oberlin Church," as the Free Congregational Church was popularly known in Hudson, hosted an antislavery convention in the upper story of the building on the southeast side of the town's central park/square. President Pierce of Western Reserve College attended with some of the alumni of the college to defend their conservative views, while Oberlin College sent its own representatives to speak. The hall was extremely crowded, but the attendants had been denied use of the old church in the center of town on the grounds that the space was

Free Anti-Slavery Church. *Courtesy of William Pelster, photographer.*

dedicated to the purposes of peaceful worship. There was a lot of heartfelt rhetoric from both sides. President Pierce's son spoke at length regarding his father's broadness of mind. A young lawyer stood to deliver his rendition of an antislavery song set to the tune of "Greenland's Icy Mountains." Case says that "the convention served largely the purpose for which it was held; that was to convert or render unpopular the views upon slavery held by the conservative elements in Western Reserve College."[100] From that point on, Oberlin College's reputation grew, and the Western Reserve College was perceived as being a bit old fashioned.

Meanwhile, the citizens of the Western Reserve were being bombarded in the local newspapers from all sides: from the North, from the South and from the floor of the U.S. Senate by the speeches of Henry Clay. Some columnists castigated the Negro for failing to take advantage of education for themselves and for their sons for the purpose of becoming successful contributors to society at large. Some touted the colonization scheme. Abolitionists were being represented as being "narrow-minded, reckless… men";[101] however, this statement by Henry Clay failed to take into account the large number of women immersed in the cause, partly because issues

of temperance and women's suffrage had somehow gotten tied up in the fight, and Clay was just as tone deaf on these matters as he was regarding emancipation. William Lloyd Garrison would see the battle as the fight for free speech, and Clay warned that abolitionists would resort to the use of force where peaceable dialogue failed to bring results. Referring to the use of bayonets, Clay played upon America's fears about the stability of the Union, pointing to insurmountable obstacles to emancipation like limiting the power of the government, the great number of slaves to be released in society without means of support and the property rights of slave-owning gentlemen. Clay foresaw a battle for supremacy between the white race and the black race would be unleashed and spoke of the "contamination of the industrious and laborious classes of society at the North, by a revolting admixture of the black."[102] This remark was clever because it touched upon the white North's fear that emancipation of the Negro would lead to suffrage for the black man and a demand to marry white women. It wasn't only the addition of black laborers to the workforce Clay was declaiming but also the amalgamation of the races already at work in the South. His words worked against him as the very whiteness of the South's slave population played a strong role in the North's demand to free them.

When Frederick Douglass returned to America as a free man in 1847 from a speaking tour of the West, he said as he stopped in Cleveland, "The whole Western Reserve [was] now in a healthy state of Anti-Slavery agitation...The people [were] fired with a noble indignation against a Slaveholding Church, and filled with unutterable loathing of a slave-trading religion."[103] The truth was that the reception that Douglass received was mixed. There were times when the great man had to sleep on deck when steamboat passengers wouldn't have him below deck; there were times when the whole ship went without dinner because white passengers refused to sit down to a meal with him. Churches closed their doors to him, where in the same town other doors opened to allow him to speak. Cleveland newspapers dubbed Douglass and his fellow abolitionists, Garrison and Foster, "the Menagerie Company," as though the circus was coming to town, advertising a new market for rotten eggs.[104] The rotten eggs failed to show up, but huge crowds of willing hearers did turn out to hear him.

Douglass's speech in Cleveland cut to the heart of the black man's inequity. He demanded "the doors of the school house, the workshop, the church, and the college...be open[ed] as freely to [black] children as to the children of other members of the community."[105] Like the widow of Jesus's parable importuning an unjust judge to get up out of bed and to do what was right,

he refused to let the matter go. As long as education and employment opportunities were segregated from the free black man and his family, there could be no real freedom for the American nation, he claimed. Urgently, he recommended free black men learn a trade, whether it be "mechanical trades, blacksmith shops, the machine shops, the joiner's shops, the wheelwright shops, the cooper shops, and the tailor shops."[106] Education was the key, and a foot in the door of prosperity was a foot forward. "Every blow of the sledge hammer wielded by a sable arm is a powerful blow in support of our career," Douglass told the Cleveland audience.[107] The Western Reserve, for the most part, found Clay's "premises unsound [regarding abolitionism], his arguments inconclusive [regarding slavery], and his deductions false."[108] From there, the Menagerie went to speak at Oberlin College, where a crowd numbering in the thousands came to hear Frederick Douglass speak under Professor Finney's big circular tent, but the abolitionists' divided message became an issue.

The abolitionist movement was meeting strong opposition, both economic and social pressures. Faced with the necessity of defending their peaceable intentions, they vowed to "never in any way countenance the oppressed in vindicating their rights by resorting to physical force."[109] But this was not the sort of violence Clay really feared—he was worried about losing the South's controlling interests in the Congress by way of the ballot box. The abolitionists, having become aware of the way that their petitions to elected representatives were laid aside unread, were out to elect officials who would represent their small noisy element in person in the halls of Congress. They had no immediate intentions of laying aside law, order, justice or, in any way, substitute violence for legislative persuasion; however, for some reason, Clay thought this "legislative violence" was out of bounds, but the abolitionists felt otherwise, stating, "Abolitionists have not changed their system of operation. Political action was intended and proclaimed from the beginning. To the employment of all constitutional and lawful means, for the abolition of slavery, they stand pledged."[110] This would eventually change, as Clay foresaw, when words alone proved ineffectual. But at Oberlin College, Garrison and Douglass would recommend "withdrawal from all political action."[111] The United States government, they perceived, was irrevocably proslave, and the two men felt that the time had come to withhold participation with an evil force. Abstaining from government or from the vote would accomplish nothing, and both men would employ their legislative voice to the full when the Anti-Slavery Society was dissolved the following year.

Antislavery politics were getting hopelessly muddled. The Whig party so dominant in the Western Reserve was too small to sway the political agenda

of any national party. They would fight things out with the new Liberty Party and lose. The Free Soil Party would become dominant in the Western Reserve. Then with the passage of the Fugitive Slave Law of 1850, Ohio burst into a state of flaming indignation. Theodore C. Smith, in his book *The Liberty and the Free Soil Parties in the Northwest*, testified that "the Western Reserve rose as one man to condemn the obnoxious bill."[112] Where all these diverse and divisive parties had diluted the emancipation fight in Ohio, making it almost certain that the Western Reserve's opinion would not be heard at the state level or in the Congress, the Fugitive Slave Bill united them. Indignation meetings were called all over the north coast, clergy actively led the charge and ex-Anti-Slavery Society members reunited. The beauty of it all was the nonpartisan nature of the protests. The Presbyterians and the Congregationalists were joined again—at least at the indignation meetings. It was a hands-across-the-aisle sort of thing that drew out influential jurists, clerics and political leaders along with the common man and woman. Judges were recommending that people be ready to disobey the law and suffer the consequences because the higher law of God took precedence, calling those who would obey the law traitors to God.[113] Free Soilers called together a regional convention protesting the new law at Ravenna, Ohio, on August 7, 1853, vowing defiance.[114] Conventions like it took place all across the Western Reserve.

Nevertheless, the situation was serious. So a group of free blacks petitioned a known abolitionist jurist, Judge William Jay of New York, for answers. His reply was disappointing, but his advice was clear. As sympathetic for the situation of the free black citizen as he was, he begged them to

> leave…the pistol and the bowie knife to Southern ruffians and their Northern mercenaries. That this law will lead to bloodshed I take for granted but let it be the blood of the innocent not of the guilty If anything can arouse the torpid conscience of the North it will be our streets stained with human blood shed by the slave catchers.[115]

Judge Jay's full reply was printed in the *Cleveland Daily True Democrat* and warned that any resistance to the Fugitive Slave Law ending in mortal blows to a slave owner or slave catcher would result in the responsible party's conviction for murder, for which the penalty would be death.[116] Jay was a champion of the Negro's civil rights. If he felt helpless, what could anyone do?

In addition, enforcement of the Fugitive Slave Law would prove inconsistent. The Western Reserve was quite a different matter than southern

Ohio, and the real problem was the kidnapping of free blacks that southern Ohio towns and courts upheld. In fact, the number of blacks rescued from slave catchers in the Western Reserve was nothing in comparison with the numbers of free blacks captured and sold back to slavery. For instance, the *Cleveland Leader* of August 1860 reported the case of James Waggoner—a free man born of freed slaves with full credentials to prove his status as a free citizen of Ohio—who had been kidnapped and then kept in jail in Kentucky for six months before being sold to pay his jail fees.[117] There seemed to be no avenue for redress. Worse, all this was getting fairly typical.

Meanwhile, the abolitionists of the Western Reserve were concerned by the stranglehold this law had gained within the state of Ohio, and an effort to protest the law upon grounds of unconstitutionality arose. In a series of essays published in the *Western Reserve Chronicle* of 1842, Ohio abolitionist Joshua Reed Giddings argued the matter with passionate diligence. The Whig party had lost its bid for power with the election of the Free Soil candidate Salmon P. Chase, but Giddings was determined to have his say and express his dissatisfaction with the outcome of the election because he felt that Chase would "lend his influence generally to the slaveholding interests."[118] Giddings's purpose was to explore the limitations of the federal government and the power of an individual state to regulate their own territory. He pointed out that the authors of the United States Constitution believed that "man is born free" and does not distinguish black from white.[119] Each state, he says, withheld from the federal government the right to decide the slavery issue personally because it was viewed as the business of the individual states.

The Puritan son insisted that

> *the sons of the pilgrims regarded slavery as a violation of the will of Heaven, and a flagrant transgression of the law of God…the people of the free States, therefore, secured to themselves the absolute right of remaining free from the guilt, the disgrace, and the expense of slavery, by withholding from the Federal Government all constitutional power, in regard to that institution.*[120]

Then Giddings refers to the English Common Law, which states that a "slave became absolutely free by entering the territory of a free State of government; whether he did so by consent of his master, or by escaping from his master's custody."[121] His point was that the Fugitive Slave Law violated both the English Common Law and the Constitution of the new United

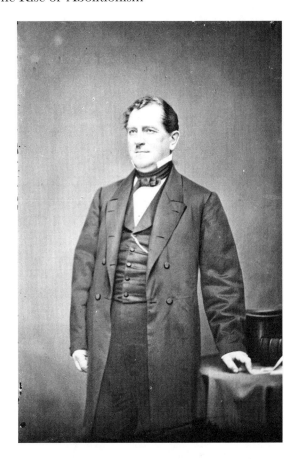

Joshua Reed Giddings. *Courtesy of the Library of Congress.*

States. Further, it trespassed on the right of individual states to make their own laws regarding slavery. Worse, the way the law was written, Judge Jay was right, and it was a crime for the black man or woman to defend themselves against the violence of the slave master or the infringement of their personal liberties even if they were on free soil when captured. This, Giddings says, is slavery and "can have no operation in our State [of Ohio]."[122] His conclusion was that slaves did have the right to defend themselves on Ohio's free soil. Giddings's position was that the slave owner could enter the state and pursue his slave, but that Ohio citizens had the right to shut their doors, teach their children to abhor slavery and to detest the slave owner and slave catcher. Further, Giddings turned the table on the slave owner and slave catcher, warning them that the laws of Ohio will not allow them to murder slaves within Ohio's boundaries with the same impunity that the slave owner and slave catcher had back in their home state.[123] In other words, the door

swung both ways. The slave owner and the slave catcher could enter the state in pursuit of their quarry, but they must abide by the laws of the state of Ohio while they were in Ohio. Further, Ohio citizens were not personally obligated to welcome them or to allow their homes to be searched. Giddings told Southern slave interests that there were no federal protections under the Constitution regarding their slave property rights, only in the constitutions of their own slaveholding states. The keep-out sign couldn't be printed any clearer. On the other hand, Giddings's remark regarding the expense of slavery cast a shadow on his argument because the North clearly intended to secure for themselves minimum wage laborers; they just intended to pay less for it than the South did when they provided cradle to the grave support. The South certainly had a valid point about the effect of minimum wage on Northern laborers that locked poor workers into poverty just as surely as a set of manacles, leaving them with no means with which to negotiate a better price for their own labor and, therefore, no hope of a better future for themselves and their progeny.

Professor Wright, Professor Green and Charles B. Storrs left Hudson to continue in the abolitionist fight. Wright became the editor of a number of famed abolitionist publications like the *Emancipator*, the *Quarterly Anti-Slavery Magazine*, the *Massachusetts Abolitionist* and the *Chronotype*, though he would end up an atheist over his disappointment regarding the church's failure to espouse the abolitionist cause. Green resigned in 1833 from the Western Reserve College and became the president of the Oneida Institute in Whitesboro, New York, turning it into a hotbed of abolitionism. Both men employed their pens to further the cause of freedom. Storrs would die shortly after leaving the college at his brother's house in Braintree, Massachusetts. His last act was to "affix his name to a declaration of anti-slavery principles."[124] The world had not heard the last from John Brown.

CHAPTER 5

FREDERICK DOUGLASS AND THE DEFENSE OF NEGRO HUMANITY

In 1854, when President Pierce led the Western Reserve College, the graduating class announced that they wished to invite abolitionist Frederick Douglass to give the commencement day speech. This marked the first time that a Negro would be offered such an honor in America. The college trustees, President Pierce and the faculty requested that the students reconsider their choice, but the class voted again to elect Douglass unanimously. Lora Case learned of the students' intent just days before graduation from the Reverend Caleb Pitkin over the supper table. Pitkin asked if Case and his wife intended to attend the ceremonies and said with a sneer on his face, "If you do, you will hear a nigger talk." Case asked if Pitkin had ever heard Douglass speak and upon learning that Pitkin had not, Case told him, "I have, and, after you hear him, I think you will like him and [think] the literary standard of the college has not been lowered by the choice of the class."[125] So Pitkin followed the band around the college chapel on July 12, entering the big tent set up on the lawn to hear Douglass speak. It was a revolutionary sight—President Pierce and Frederick Douglass walking at the head of the procession—entering the tent together to take their seats on the speaker's platform. Lora Case said, "From that time on and due largely, I think, to the speech of Douglass, the opposition to anti-slavery waned until by the time Hitchcock became president, the majority of the trustees and faculty became opposed to slavery.[126]

The Western Reserve College. *Courtesy of Hudson Library and Historical Society, photographed by William Pelster.*

The Reverend Caleb Pitkin. *Courtesy of Hudson Library and Historical Society, photographed by William Pelster.*

Frederick Douglass and the Defense of Negro Humanity

Frederick Douglass accepted the invitation to speak at the Western Reserve College on the advice of friends. After all, it would have been a dreadful shame to turn it down. Nevertheless, he admitted that it was "with much distrust and hesitation that he accepted the invitation."[127] As a commencement day speaker, he was an unheard of choice where one would have expected an educated white man of high social, political or intellectual distinction. So Douglass decided that "it [wouldn't] do to give [his] old fashioned anti-slavery discourse."[128] This was an excellent decision on his part because there was no question but that the halls of academia were on the lookout that day for any of the "bad grammar; talk, and those expressions which the public have appropriated to his race."[129] Both the man and his race were on trial here. Assuming himself to be a welcome guest and desiring to prove himself worthy of the honor, he wanted to make a show of his literacy. So with the aid of Dr. Martin B. Anderson, president of the University of Rochester, he prepared a formal speech. This was not his usual form of oratory, which normally relied upon his powerful storytelling skills. Instead, he borrowed the book *Man and His Migrations* by Dr. R.G. Latham and a large tome written by Dr. Morton, a famous archaeologist, along with the new work by Nott and Gliddon on the *Types of Mankind: or, Ethnological Researches*. Basing his arguments on these and on a book he'd seen in England, Dr. Pritchard's *Natural History of Man*, he prepared a formal speech in manuscript form that he felt worthy of the occasion, never dreaming that his usual antislavery discourse would be more suitable to the audience's needs because, in Hudson, the "faculty, including the President, was in great distress because [he,] a colored man, had been invited to speak and because of the reproach this circumstance might bring upon the College."[130] Fortunately, the graduating class stood firm by their choice, even though not every member of the faculty agreed with the president and the college trustees as to Douglass's suitability as a speaker.

The festivities began on Sunday, July 9, 1854, at three o'clock in the afternoon with President Pierce's baccalaureate discourse. Douglass was to speak before the two college literary societies on Wednesday just after lunch on July 12. Unknown to Douglass, the young man who had instigated the invitation to speak was under pressure to cancel the engagement. It seems that young Mr. William Sheldon Kerruish, a sophomore at the Western Reserve College, had been brought up as an antislavery man back home in Warrensville, Ohio. In addition, the young man's family subscribed to the *National Anti-Slavery Standard* published by Frederick Douglass. Finding that it was the practice at commencement to invite some distinguished scholar or politician to come and address the graduating class with a few *bon mots*, Kerruish suggested that

an invitation be issued to Douglass.[131] This proposition, when it was presented to the college faculty and trustees, found little favor in their eyes. In fact, they were appalled by the thought of an illiterate Negro being honored in such a way, feeling it to be inappropriate in the extreme.[132] As Kerruish had been the source of the movement to invite Douglass to speak, President Pierce sent for him to talk him into getting the candidates for graduation to reconsider their choice. In addition, another professor, who was a minister of the gospel and professor of mathematics, also sent for Kerruish, complaining that the college would be disgraced publicly and academically for issuing such an invitation.[133] Kerruish insisted that Douglass was not illiterate, that he had read Douglass's paper and that he felt Douglass would do a good job. Therefore, with the help of a friend, the sophomore managed to pass a resolution to issue Douglass an invitation to speak. Nevertheless, the graduating class of five students was concerned that there might be trouble, and they waited anxiously for Douglass's answer, which was a long time coming; however, when the day came, the assembled crowd numbered in the thousands—the largest gathering the town of Hudson had ever seen on commencement

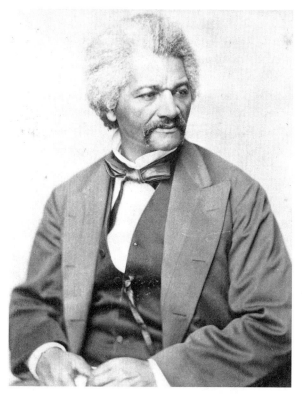

Frederick Douglass. *Courtesy of the Library of Congress.*

day. In addition, President Pierce invited Douglass to his home as a guest, as though the invitation had been his own idea.

Kerruish hid behind a big post rather than take a place on the backless bench seats provided for the audience, fearing disaster. Only when he saw a dignified Douglass walking beside the president with a look of self-possession in his countenance did the young man relax.[134] Douglass marched around the chapel behind the band at the head of the procession with Pierce, entering the big tent and mounting the speakers' platform. Then he looked around at the audience with composure. He made a few humorous remarks about the distance he'd traveled in his lifetime to reach this place—from his life as a slave living on a Southern plantation to stand before these learned men on commencement day offering words of advice to a new generation of scholars. He was an excellent public speaker, and the expected disaster failed to present itself.[135] Afterward, Douglass would pronounce the address to be less effective than his usual rhetoric, but the audience who heard him felt it had gone well. In fact, it went so well that there was soon a demand to read it in print, but Douglass had to take care of that himself. Even the professor of Greek and Latin admitted that the colored man must be the son of some great Southern gentleman.[136] This was damning with faint praise if Douglass's only claim to eloquence was a bastard connection with a Virginia slave owner; nevertheless, the faculty could find no fault in the address even if they disagreed upon issues of colonization versus abolitionism. Douglass's natural dignity and easy bearing was a more eloquent testimony to the Negro race's quality and character than anything he actually said. The letters to the editor column preserved a dignified silence that spoke volumes all on its own. Still, as Lora Case said, hearts had been moved and minds opened—a step forward toward emancipation and equal rights for all.

Most importantly, Douglass held his own in august company, and "a gentleman of the town who had resided in Hudson since [the] formation of the College, remarked that, except in a single instance, no man had ever commanded so good attention."[137] Douglass had a melodious voice that was easy to listen to and provided full range to his emotions. He was neither a monotone speaker nor a shy one. This discourse enveloped his life experience and included competent scholarship, even if it were not quite as polished in delivery as he had hoped. Reading from a manuscript tied him down a little; however, the theme of his discourse, "Claims of the Negro, Ethnologically Considered," was incendiary and puzzling to the modern mind. It might be expected that Douglass's primary concern would be to urge the nation's new leaders passing from the halls of learning to use their

professional credentials to press for the emancipation of the nation's slave population even if he didn't want to complicate the discussion with issues of citizenship and suffrage for the Negro. Douglass, though, went back to the very roots of the problem—the fact that the Negro had been legally defined as less than a man, held almost on the level of livestock in some people's eyes. So it was to make a case for the humanity of the Negro race that he had come to speak to the gentlemen of the Western Reserve College.

At this time, a great deal of effort was being expended on the part of clerics, philosophers and men of science to reconcile science with the Bible's story of creation. The question of man's origin led to inquiries regarding the origins of racial and ethnic differences—questions about God and creation itself. Did the things men of science were learning about man and his world measure up to the account of creation in scripture? What were Christians to believe? The world that was soon to read Darwin's *Origin of Species* was already discussing the concept of evolution and had opened a Pandora's box of interrogations. A lot of people were uncomfortable with the possible answers, and the Western Reserve College, founded by Presbyterian and Congregational ministers, would be acutely so. Meanwhile, scientists attempted to fit all the theories in together under the same roof. Textbooks of the time went into great detail measuring and comparing each human component of the black man and the white man. Then they compared each race and nationality with each other in an attempt to see which race or ethnicity was superior. It was an easy leap for some to decide that the Negro was naturally inferior to the white man, and a host of calculations and measurements that included the shape of the skull and the size of the brain cavity were used to bolster that supposition. The suspicion that the Negro was not even human was a comfortable one because it meant that the Negro could lay no claim to social equality or demand equal opportunity as citizens. It lent an aura of moral support to the institution of slavery since man must care for animals as his God-assigned task, yet never on terms of equality. To support this argument, therefore, the Theory of Polygenesis developed, which defined the human race as a unique species separately created by God to which the Negro did not belong.[138] A wild number of theories diverged from here, all intended to support the white man's claim to be the superior creation and a separate creation from the black man.

It was the Theory of Polygenesis that Douglass had come to dispute, but to understand the reasons why Douglass's topic held the rapt attention of the college's two literary societies for two full hours on a sweltering July afternoon, it is necessary to understand the full malevolent nature of this

pervasive argument. Charles Carroll's book *The Negro a Beast*, published in 1900, explains the emphasis ethnologists adhering to the Theory of Polygenesis placed upon the words of Genesis, chapter two, where it says, "And God said, Let the earth bring forth the living creature after his kind; cattle, and creeping things, and beasts of the earth after his kind; and it was so." The description of man's creation that follows is shown to be a separate act, separate from the creation of the beasts of the earth. Linking this scripture with the words of the Apostle Paul at 1 Corinthians 14:39, which reads, "All flesh is not the same flesh; but there is one kind of flesh of men, another flesh of beasts, another of fishes, and another of birds," Carroll's text makes a case for the beast being a distinctly separate creation from that of human beings or of animals—separate as well from Adam and Eve and their progeny. Then the book ties the beasts described in Genesis with the Negro, denying their humanity and their claim to descent from the first human pair. The author was not the first to draw these connections; he was merely summing up a century of discussion and documenting it. Nevertheless, Carroll goes on to claim that God only intended one species of human beings—the white man. The beast, he claimed, was merely a biped animal of lower intelligence intended as a domestic servant to the man, resembling humans but inferior to them and a separate species/creation altogether. All other races and ethnicities, he claimed, had come about through the "amalgamation" or interbreeding of the Negro beast with humans—a bastard connection. This tied in nicely with purist desires to treat the incoming European immigrants, Asians and Native Americans similarly to the Negro as separate, inferior nonhuman species. Carroll is particularly suspicious of Eastern Europeans' pure human status and blames Asian/Mongolians for tainting European bloodlines with Negroid bloodlines. Further, he claims that this sin of amalgamation was at the root of Cain's loss of God's favor and of Ham's fall from grace—an irrevocable loss of their progeny's human status. This purist doctrine excluded just about everyone but those of English extraction, claiming that any who bore the taint of Negro blood was no longer truly the progeny of Adam and Eve. He also claimed that such persons were not heirs to the promise of salvation through Jesus Christ because this promise was made only to the offspring of Adam. So that the Negro and their mixed blood progeny were permanently exiled from the human race and from the gospel of salvation.[139] This is what made Douglass's topic so important, and why it was so critical that he use the platform that he had been offered to establish the Negro's claim to humanity.

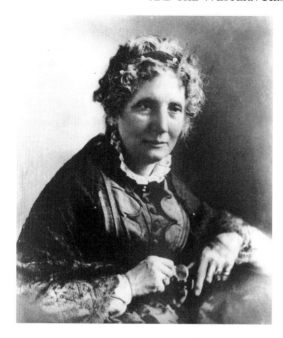

Harriet Beecher Stowe. *Courtesy of the Library of Congress.*

It is to be remembered that it had only been two years since Harriet Beecher Stowe's *Uncle Tom's Cabin* had become a best-selling novel. (Stowe's father, Lyman Beecher, was a Congregational minister and the first president of the Lane Theological Seminary in Cincinnati, Ohio.) The powerful story was designed as a tearjerker to soften hard hearts that could support the separation of husband from wife and children from parents on an auction block. To be sure, it was on the melodramatic side, but the story struck a chord in the hearts of honest hearers. Its focus was to get people to feel the pain of the Negro when many assumed Negroes to be dumb animals with no sense of family connection or human affection. The book was not as strong or as subtle as Harriet Martineau's nine-hundred-page novel *The Hour and the Man*, designed to be an fictionalized biography of the leader of Haiti's successful slave rebellion, François-Dominique Toussaint L'Ouverture, showing the black leader of the rebellion as a man of character, intelligence, a loving father and a husband—a human being. Nevertheless, Stowe's book brought the action to American shores and into American drawing rooms where honest Northern men and women saw the incompatibility of the slave state, their faith, church structures and the American Constitution. Finally, there were people willing to listen to a black man and learn.

Douglass tells his audience first of all that neutrality on the subject of the Negro's claim to being a member of the human species is unacceptable. His words of a battlefield calling them to action where a lukewarm response might prove deadly are ominous to those who realize that many of these young men would go to war not long after this speech. He refers to the South's denial of the manhood of the Negro as the entire basis of their claim to rightfully enslave the black man and woman and their progeny. Still, he pressed the audience to admit that "the negro has the same right to his liberty" that the free peasant does.[140] Here he was not arguing quality of life, for both the free peasant and the slave may actually experience similar lifestyles and brutal manual labor. What was different, he said, was the total lack of opportunity for the slave or his progeny to progress economically to a higher station in life, whereas the free peasant had the hope of doing so—if not in his lifetime, then in his children's or grandchildren's lifetimes. Freely calling the institution of slavery "robbery," Douglass admitted that he felt himself to be "somewhat on trial."[141] It was a brave thing for a man who had taught himself to read to stand up before such distinguished scholars and presume to teach them. Certainly, he was aware by this point that the invitation to speak had not been initiated by the gray-bearded college elders. Further, he knew that the Negro was denigrated as having inferior mental faculties, and he exclaimed to his audience out loud the injustice of comparing him and those of his underprivileged race to auditors like Henry Clay and Daniel Webster, with their elitist educations, using such unfair comparisons to decry the Negro's intelligence.[142] His point was that education hones intelligence; it does not create it. Using a person's lack of education as proof of his or her low intellectual capacity was a completely false premise. Here his audience is reminded that the entire fate of the Negro race in America may be irrevocably stifled based on Douglass's own performance that day. Neatly, he points out that even his dog and his horse knew him for a man.[143] Therefore, his learned audience should not require further persuasion unless their privileged educations had removed from them all common sense and placed their intellects beneath the level of the animals.

The question now debated by men of learning the world over was whether the races of men arose from a single source and how that might be when like begets like. Of course, the assumption by those adhering to the Theory of Polygenesis was that the first human pair was white and could only have born white children. Wisely, Douglass fell back on the words of the Apostle Paul that "God has made of one blood all nations of men for to dwell upon all the face of the earth."[144] He relied on scripture to make his case for a common

origin for all men. To an audience made up of clerics and future clerics, this was a good move. They needed to choose between their Bible, their faith and their developing science if they were to espouse the concept of multiple-created, human-like species. In a broad hint, he told them that "one seventh part of the population of this country [i.e. America] is of negro descent."[145] His point is clear. A seventh of the population of the nation cannot continue to be ignored, swept under the drawing room carpet or shelved on a side table of Congress. As the white man's brotherhood with the black man was recognized, he said "the rights, privileges, and immunities enjoyed by some must be shared and enjoyed by all."[146] Now there was a scary thought to present to the elders of Hudson and the Western Reserve College, and it presented a threat to their carefully cherished personal ownership of the Western Reserve. In their favor, they gave him their honest attention.

At this point, Douglass turned the subject with the purpose of engaging the audience's sympathy to the enslaved Negro's plight while dispelling fears of harmful repercussions that might result from immediate emancipation. He pointed to the example set in the British West Indies where for too long the slaves were denied "baptismal and burial rights."[147] This, again, was a good move because the concept of denying baptism and burial to fellow Christians was foreign to the Nutmegers, and the remark was calculated to bring a positive response from his audience. He spoke of the way that emancipation and Christian religion had successfully joined hands in the British West Indies to the praise of God. Again, he knew the missionary-spirited inclinations of his audience well. Accepting the Negro as their brother would swell the ranks of Protestant Christianity worldwide. From here he warned "once granted that the human race are of multitudinous origin…you make plausible a demand for classes, grades, and conditions… and a chance for slavery as a necessary institution."[148] To the people of the Western Reserve who prided themselves on their nonstratified society, this remark was also well placed. His point was that the slave interests of America were behind the movement to denigrate the humanity of the Negro, and that the word of a prejudiced person or persons should not be allowed to form legal precedence in this or in any case.

It certainly wasn't for the economic good of the North that the South should hold the power to sway the American Congress's economic policies to support slavery. On the contrary, the economic dominance of the South was clearly the object of the racial prejudices propounded by the gentlemen of the South. Douglass's words echoed those of Joshua Reed Giddings, Ohio's serving member of the U.S. House of Representatives in 1854, who

decried such policies in his series of essays published in the *Western Reserve Chronicle*. Giddings pointed out how race hate and Southern influences crippled the economy of the new United States by refusing to trade with the people of Haiti when the rest of the civilized world acknowledged the self-emancipated slaves, opening diplomatic relations with them. In Giddings's view, Haiti's "acts of valor and patriotism…entitled [the new country] to a rank among the governments of the earth."[149] He likened Haiti's slave rebellion to America's break with England. The government of France and England had recognized the island people's free status, but the United States government moved early in the century to block economic relations with Haiti. Giddings says that this was done deliberately "because most of [the Haitians had] been slaves and it was designed to withhold from them our provisions in order to bring upon them famine and distress, lest their example might induce the slaves in our southern states to assert their liberty."[150] The economic loss to Haiti, he says, was also a tax upon the economy of the Northern states of the Union for the benefit of supporting the slave states of the South.[151] So the point that racial prejudices economically harm those who hate as well as the hated was made.

Douglass's speech continued to discuss in derogatory terms the study of ethnology, an alleged science used to downgrade the Negro race. He pointed out that the Egyptians, known the world over for their intelligence and highly developed civilization, were not white; in fact, he claims them as mulattos like himself. Then he made his own case for kinship with the builders of the pyramids and through them to the original human pair. His target was Josiah Nott and George Gliddon's publication made recently available, *Types of Mankind or Ethnological Researches*—the likely source of Charles Carroll's boiled-down version of racial prejudice that would be published a half century later. It was a book the scholars seated on the platform beside him and before him were likely familiar with and currently discussing. This book pretended to use scientific process to prove the white man's superiority over all other races on the earth. Nevertheless, as Douglass attempted to make use of climate and environment to explain the Negro's physical differences from the white man, he seemed to realize how superfluous his arguments were. Calling himself up short, therefore, he said, "Human rights stand upon a common basis… arising out of a common nature."[152] Further, he pointed out that the citizens of America shared a common history from the very beginning of their time together. It was the native soil of the white man and the black man; it was their home; it was the place that they have built together.[153] Succinctly, he told the leaders of the college that the plans of the American Colonization

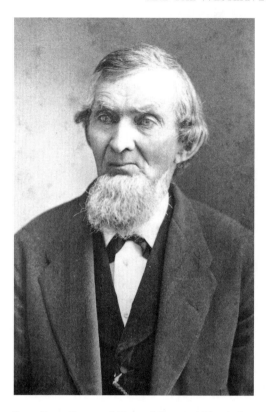

Lora Case. *Courtesy of Hudson Library and Historical Society, photographed by William Pelster.*

Society to remove the Negro race from American shores was unacceptable, telling them that they must prepare themselves for a united future. He wasted no further argument on the topic than this bald refusal to comply with the colonization scheme, ending with a scripture attesting to the truth of his words and reminding the audience of their shared Christian faith.

Although the speech was not given with Douglass's usual extemporaneous flair but a work of unaccustomed scholarship that he read from a manuscript to the audience, his listeners were much impressed. That his diatribe intended to claim kinship with the great houses of Egypt would prove unsound was not the point. The point was that he had stood up among scholars and held his own, though he had been "born…in obscurity, a stranger to the halls of learning, environed by ignorance, degradation, and the concomitants, from birth to manhood."[154] Nevertheless, he had championed Negro humanity and earned the respect of the scholars of the Western Reserve College.

Caleb Pitkin told Lora Case later that day that aside from Douglass's views about the American Colonization Society, he could find "no fault" with Douglass's address to the college. William Sheldon Kerruish transferred from the Western Reserve College the following year to finish his degree at Yale College, becoming a leading attorney in the city of Cleveland and practicing law into the new century, well into his eighties.

CHAPTER 6
FIRE IN THE HOLE

I t was on September 13, 1858, that a U.S. marshal used the Fugitive Slave Law to arrest John Price in the village of Oberlin, Ohio, and the town just about exploded. The home of the abolitionist college of Oberlin had become a haven for freed Negroes and runaways, and the little town's mission was to protect them. The arresting officer, U.S. deputy marshal Lowe of Columbus, therefore, removed Price from Oberlin as quickly as possible, taking him to the Wadsworth Hotel in Wellington, Ohio, to await a train to the state capital. Nearly every man in Oberlin with a wagon or a carriage followed close behind. Others ran on foot. Soon a mob consisting of both races surrounded the Wadsworth Hotel, threatening to tear down the house. Oberlin leaders and college academics stood discussing the warrant they had been shown that lacked an official seal. They weighed the option of obtaining a writ of habeas corpus as a means of securing the kidnap victim, who was looking out at them from an attic window. In the end, the crowd broke in to get to Price and drive off with him.[155]

The Western Reserve of the 1850s was heating up, and it was no surprise that the trustees and faculty of the Western Reserve College should have been so distressed by the graduating class's choice of commencement day speaker. It didn't take a psychic to see that things were getting out of hand. All a person had to do was open the local newspaper to know that. On May 24, 1854, shortly before Douglass's address to the college, a black man named Anthony Burns was arrested in Boston, Massachusetts. Newspapers

throughout the Western Reserve took deep interest in the event because Burns was a fugitive slave, arrested under the Fugitive Slave Law. Two days after Burns was arrested, the Boston courthouse was mobbed by abolitionists of both races. In the course of the riot, a U.S. marshal by the name of Batchelder was shot and killed, leaving a family behind. Government troops were sent to maintain order as antislavery men flowed into Boston, and William Lloyd Garrison publicly set fire to a copy of the Fugitive Slave Act. The trial and outcome was followed assiduously in the Western Reserve, and local papers were all over the subject. Burns lost his bid for freedom, and some people were calling for justice over the murder of Batchelder. Soldiers held the town of Boston at bay while Burns was shipped back to slavery. The president sent word of his approval regarding the Boston marshal's actions in upholding the law. Sympathetic antislavery forces purchased Burn's freedom thereafter, and Anthony Burns received his education from Oberlin College, Ohio, becoming a Baptist minister in Canada. In Ohio, as the news of the Burns affair was all over the telegraph wires, an attempt to kidnap a Negro barber in the village of Akron was scuttled by alert citizens; an indignation meeting was later called.[156] Without question, the Western Reserve was spoiling for trouble.

All over the West, antislavery men were losing the battle to Southern slave interests. The Missouri Compromise of 1820, designed to keep the number of slave and free states in balance, was crumbling. The South was openly jeering at the North. Their alleged contrition for the sin of slavery was seen to be a sham. The *Ohio Observer and Register* on June 28, 1854, reported that slavery was open and operational in the new state of California. Slave owners were being allowed to bring in Negro slaves and were being given continual extensions, allowing them to remain in control of their property. A mission teacher by the name of Richard Mendenhall, who was working at an establishment controlled by the Methodist Church South, wrote to inform Northern readers that slaves were being used to perform menial work in the Kansas territory and in Nebraska, and that the goal of the mission was to convince Christianized Indians to move out of Nebraska altogether, while doing everything in their power to get the Kansas-Nebraska Bill passed. Further, the superintendent of the mission, Thomas Johnson, had been elected to Congress and charged with the task of passing the Nebraska Bill to ensure the spread of slavery into that territory. In other words, the South was actively expanding beyond the agreed upon thirty-six-degree, thirty-minute longitude line. They were using the Fugitive Slave Law to call the shots in the North, attempting to remove all protections from the colony of

Liberia and had no intention of abiding by the territorial boundaries set on slavery in violation of their own interests. Frederick Douglass's visit to the Western Reserve College couldn't have been timed any better. The situation was combustible, and the faculty and the trustees of the college had every right to be concerned.

The South was also using the tool of popular sovereignty for new states to legislate more slave states than the federal law allowed. Northern abolitionists saw the battle for emancipation was being lost in a humiliating way. Southern members of Congress were openly insulting. In the House of Representatives, it was reported that Stephens of Georgia called the members from the North a "mouthing, white-livered set" when the Nebraska Bill came under discussion.[157] Stephens mocked Northern members openly regarding their useless "hissing," telling them that their opinions didn't matter in America any more—the South would "lash [them] into obedience."[158] Worse, it appeared Stephens was right, that the North was helpless because the South had no shame where it had no morals to guide them, and the North was hampered by their Puritanical devotion to doing what was right as peaceful, law-abiding men. Nevertheless, the North was acutely aware that their own morality was being used against them. They were not only being used as the South's puppets, but they were also actually in danger of being enslaved to the laws of the South in their own state of Ohio. At the same time, all they could do was watch as large slaveholders from Virginia and Maryland made plans to develop plantations in the Southwest, out of reach of abolitionist agitators along the Gulf of Mexico.[159] Then just days before Frederick Douglass's speech at the Western Reserve College, word came that Mr. Slidell of Louisiana had proposed to the Senate that the "U.S. Squadron, which [had] been kept on the coast of Africa to suppress the slave trade be removed."[160] It could only mean the resumption of the slave trade. The men of Hudson called a meeting of the anti-Nebraska men of Hudson on June 30, 1854, to choose representatives for the county convention: the Honorable Judge Van R. Humphrey, John Markillie and Henry Bristol. Their purpose was to "present to the citizens of the United States Thomas H. Benton as a candidate for the next Presidency."[161] Meanwhile, proslavers were at work in Washington laying claim to Indian lands before antislavery men could have an equal opportunity to stake a claim in Kansas and in Nebraska in order to establish citizenship there.[162]

In addition, the American nation was facing the prospect of war with Spain, England and France over the situation in Cuba. England and France were demanding that Spain free the slaves of Cuba and convert to a free

labor system on the island—as if anyone needed more racial tensions added to the pot. This alleged freedom was questionable, as England meant to fill the labor gap with indentured contract laborers from India, the Pacific Islands and China.[163] A number of proposals were put forward, like Cuban slaves being allowed to hire themselves out to other people if they paid a portion of their wages to their master. In addition, a plan was afoot to bring in free African laborers to displace black slave labor on the island, promising free public schools and raising the possibility of blacks intermarrying with whites. Fears of a loss of white supremacy in Cuba sparked fears of slave uprisings among the nation's Creole population. The *Ohio Observer and Register* of June 28, 1854, reported to Hudson readers that Cuba's efforts to defend itself from invasion by recruiting freed blacks and mulattos for the Spanish army had generated a crowd of Negroes in Belen Square, Havana, saying, "Their cries for arms generated universal alarm."[164] Certainly, the slave owners of Cuba were alarmed and began to set about a petition on the subject, but they were warned off by the Captain General. The free blacks and mulattos were to comprise a "third of [Cuba's] military force, and were to serve in all the various requirements in detached companies" as regular Spanish soldiers.[165] The only good news was that Spain was not planning to invade the New World any time soon.

The mental image of masses of Negroes being handed arms would have raised different responses in the Northern United States than in the South. In the South, concerns of invasions by armed black soldiers preaching freedom to their slaves had them frightened. Sugar planters worried about their market prices if they were going to be competing on the world market with Cuba. Nevertheless, as Frederick Douglass spoke to the gentlemen of the Western Reserve College regarding the excellent results experienced under emancipation in the British West Indies, they would have had this contrary image of violence at the back of their minds, wondering if their sons would die in Cuba. The question of how much they meant to risk in the cause of emancipation and what that would mean was certainly an issue. Meanwhile, a movement rose in Congress to purchase Cuba from Spain because the new American nation was still in an expansionist mode—the concept of Manifest Destiny having taken hold—and desired to rid their corner of the world of other great powers as they had England and France. They certainly didn't want Spain invading the New World again in defense of Cuba and violating the Monroe Doctrine. On the other hand, a number of people worried that the South would only use the situation to expand its slave empire into the Caribbean. Southern slave interests were already

entertaining dreams of expanding into South America through Brazil should they acquire dominance in the Caribbean islands, and a counter movement to proactively invade Cuba began in the South with the purpose of undermining Cuba's economy.

This same month of June 1854, the Kansas-Nebraska Act was passed in Congress due to the labors of Senator Stephen A. Douglas of Illinois. Douglas complained to Ohio's governor, Salmon P. Chase, about the burning effigies representing his person that he had seen on his trip into Washington as he passed through the Western Reserve that were "hanging by the neck in all the towns in which [the abolitionists] had influence."[166] Yet, Ohio was not deceived by Douglas's claim regarding the bill's democratic nature. The Kansas-Nebraska bill left the question of slavery up to the few white inhabitants of these two large territories and hampered the immigration of abolitionist forces by "insert[ing] a clause providing that no persons other

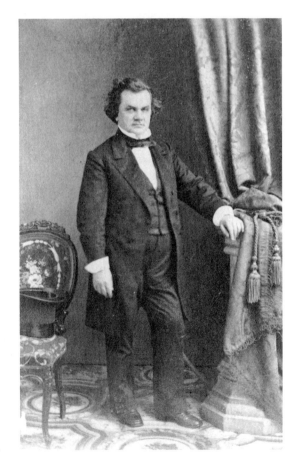

Senator Stephen A. Douglas.
Courtesy of the Library of Congress.

than citizens of the United States should hold office or vote until they had sworn to support the principles of the [Kansas-Nebraska bill]."[167] European immigrants attempting to flood the West to stake a claim in these territories were being turned back at the borders by the boatload. Of course, black citizens need not apply, and it was clear to everyone that the bill that had initially come about to make the Transatlantic Railroad possible had effectively repealed the Missouri Compromise.

Activists were up in arms. The first thing to do, they felt, was to agitate for repeal, and the second thing to do was to immigrate to Nebraska and Kansas and qualify to vote in the election that would determine the slave versus free status of these two territories. Unfortunately, both sides had the same idea at the same time. Newspapers reported that large numbers of Massachusetts's gentlemen were leaving their homes "to find a home on free soil, and with an honest purpose to keep it free."[168] Beauteous descriptions of Nebraska's fertile land flowing with game and wildlife were printed in Western Reserve newspapers in the hopes of enticing abolitionists to pack up and move west. They made it sound so easy going where few white men had gone before, a land inhabited by Indians as their "grandest hunting ground."[169] Certainly the descriptions of a new Eden would be inviting to the descendents of the Puritans, and the thought of all those non-Christian savages enjoying God's bounty, living the free life, was enough to make any man pack his prairie schooner. After all, they saw this land as their inheritance. The fact that there were proslavers with slaves moving into the new territory for the purpose of outvoting Free Soilers drove the agenda. Everyone seemed to know that it was going to come down to a fight between the two factions, which added the spice everyone was looking for. Certainly it appealed to the John Brown family, and John Brown would follow four of his sons out to Kansas to join the fight.

Luke Fisher Parsons describes the Kansas that was in the book *With John Brown in Kansas: The Battle of Osawatomie.* The Kansas-Nebraska bill promised that the slave status of these two territories would be left to the people to decide by popular sovereignty, but the gentlemen of the South had no intention of allowing Northern sympathizers to have a fair chance to weigh in at election time. Every election, proslavers flooded over the border from Missouri to block Free Soilers from voting. When Parsons arrived in Kansas, he was able to purchase a claim cheaply because the previous owner, Mr. Macy, said his wife was ill and needed to return east. The truth came out soon enough when Parsons returned to his cabin to find a note pinned to his door that read, "No Yankees wanted here; did

not Macy tell you?"[170] The territorial government was under the control of proslavers, and they had the backing of the local U.S. marshal aided by government troops. Any semblance of law and order was a complete sham, and armed marauders were burning out abolitionist homesteads, killing the men, stealing the livestock and threatening the women and children—it was anarchy. That was when John Brown stepped in with his four sons—Owen, Frederick, Salmon and Oliver—saying, "Do you know who they are?...I'll attend to them."[171] Brown's goal, he claimed, was to save the women and children, then themselves if possible. The fight was against four hundred armed men lugging a brass canon.[172] Certainly, that factor played a role, and neither side was playing by the Queensbury Rules. Yet, when Brown said in a speech given in Cleveland on March 22, 1859, that "he had never killed anybody, although on some occasions, he had shown the young men with him how some things might be done," it seems clear he was being deliberately mendacious.[173] The *Cleveland Plain Dealer* reported Brown as saying, "He believed in settling the matter on the spot, and using the enemy as he would fence stakes—drive them into the ground where they would become permanent settlers."[174] If the few citizens of the Western Reserve in Brown's sparse audience that day had any doubt as to his guilt, it was now clear—he felt no guilt, neither was he innocent. The truth is that Brown

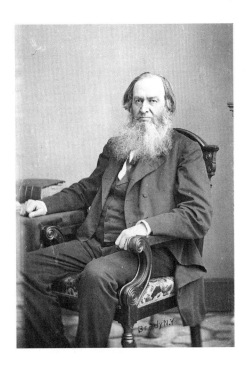

Gerrit Smith. *Courtesy of the Library of Congress.*

had gone to Kansas knowing that it would come down to a bloody battle. In August 1855 at the ultra-abolitionist convention held in central New York State, "Gerrit Smith presented to John Brown in open session, seven voltaic repeaters, seven broad swords, seven muskets with bayonets, and a purse of gold: and told him to go to Kansas with his remaining sons with him, arm them; and, as he had promised, make a faithful report of his action on behalf of human freedom."[175]

So that while many naïve idealists went out to Kansas and Nebraska with the honest purpose of staking a claim as settlers to have their peaceful say at the ballot box, Brown came armed for battle and intended to have one. Parsons described the lumber wagon drawn by a skeletal horse that brought John Brown, Theodore Weiner, son-in-law Henry Thompson and his four sons into town, each man armed to the teeth bearing weapons matching in description to the weapons that Gerrit Smith had given Brown. They didn't come peaceably just to vote; neither had the proslavers. They were fighting an undeclared war, and the gloves were off. In Parsons's mind, the Battle of Osawatomie ranked in the fight for freedom right along with the Battle of Bunker Hill. Certainly, it turned the tide toward making Kansas a free state, and the Free Soilers of Kansas were quietly grateful to John Brown while deploring his methods. The savage murder/mutilation of the men Brown had vowed to "attend to" was alternately attributed to Comanches, John Brown or his sons, depending on the historian's politics.

The people of the Western Reserve followed reports of the Kansas massacre with their hearts in their mouth, wondering if their native son, John Brown, was dead, but the man who returned to them was disappointed by their lack of interest. With a price on his head, Brown walked by the U.S. marshal's office daily without attracting attention. The Western Reserve was awaiting the outcome of the Oberlin Rescuer's trial, and Brown wasn't the only pebble on the beach. Disappointed by the profits his speaking engagement engendered, he told his followers that they would have to keep themselves for a year while he scrounged for the money to fund his intended assault on the government arsenal at Harpers Ferry. Meanwhile, Joshua Reed Giddings called for a massive convention of the Anti-Slavery Society to meet in Cleveland on May 24 as they awaited the court's decision regarding the Oberlin Rescuers. Delegates filled railroad cars. They came from Elyria, Oberlin, Cincinnati and Columbus. They came from all over the Western Reserve, and even Pittsburgh, forming a procession at the railroad depot and marching to Cleveland's Public Square and the Cleveland courthouse/jail. In addition, Ohio's senator, Edward Wade, and Ohio governor Salmon P.

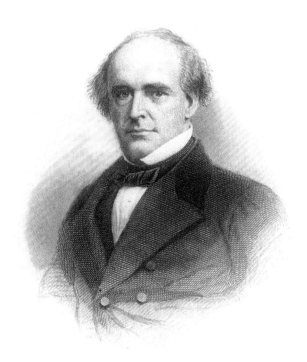

Salmon P. Chase. *Courtesy of the Library of Congress.*

Chase graced the event, and it is estimated that the crowd numbered in the realm of ten to twelve thousand men.

Giddings addressed the crowd, insisting that in pursuit of liberty the use of force to resist the Fugitive Slave Act was permissible. This opinion could be expected coming from the descendents of Revolutionary War veterans. The crowd was revved, but when Governor Chase took the platform, he recommended caution and judicious use of the ballot box, not insurrection. He pointed out that the current government was the creation of the American people, and there was a due process—a pathway to follow if the people wanted a law changed. He admitted that he had always seen the Fugitive Slave Act as an imposition of Southern policies upon the North, and he agreed with the crowd that John Price had not only been denied due process under Ohio law but also that the methods that the slave catchers had employed were illegal in the state of Ohio. Still, he urged nonviolence, and so the crowd dispersed, vowing to stand up for the cause of liberty, publicly denouncing the Dred Scott decision and the Fugitive Slave Act and providing for a fund to be set aside for the defense of republicanism and liberty.[176] In the end, all but two of the Oberlin Rescuers were released unscathed:

"The government…backed down and fully discharged the Oberlin Rescuers without trial or any concession on the part of the prisoners. One hundred guns [were fired] in honor of the victory."[177] Talk about a high—Oberlin's higher-law-of-God principle had triumphed, and all was right in the Western Reserve's Puritan world. The *Cleveland Leader* reported, "The evident attempt to enforce the Fugitive Slave Act on the Western Reserve by government officials, for political effect, has resulted in a most disastrous defeat."[178] Nevertheless, everyone knew that there was more work to be done, and the Western Reserve's John Brown had taken it on as his personal mission.

In July 1859, therefore, Brown rented a Maryland farmhouse under the name of Isaac Smith where he and his followers collected in preparation for an assault upon the government arsenal at Harpers Ferry, Virginia. The plan went off rather smoothly, with little local resistance offered, but he was captured just as swiftly. Yet the broader issue presented by Brown's ill-advised actions was the hysteria it tripped off. This was not entirely unwarranted nor was it entirely Brown's doing. Both the North and the South were to blame, and the argument reached back into the roots of the American Revolution in the principle that any government that trespassed on human rights had gone too far. Nevertheless, while Brown may have miscalculated the response to his illegal actions from enslaved Negroes, the response from Governor Wise of Virginia was everything that he could have wished for when authorities found a trunk belonging to Brown containing seven maps. These were maps of South Carolina, Georgia, Mississippi, Louisiana, Alabama, Kentucky and Tennessee. The maps were marked, detailing plans of invasion and showing plainly that Brown's offensive was not intended to stop at Harpers Ferry. The trunk also contained letters from sympathizers and a journal detailing contributions to the cause. So the notion that Brown had failed to think out his plan beyond taking the arsenal at Harpers Ferry is false, and the degree of planning, documented by the contents of the trunk, showed logical premeditated intellect, not insanity. In other words, claims that Brown was insane were exaggerated and unfounded. These maps were matched up with population statistics indicating the slave-to-free white population. Brown based his odds of success on a high Negro population in the areas marked. What he didn't count on was indifference from enslaved blacks. John Henry Zittle's account of Harpers Ferry tells of a slave "belonging to Colonel Lewis Washington (General Washington's great nephew)…[who] was offered a pike [by Brown's invaders with which to fight for his freedom] which [the boy] refused, [saying] 'I don't know anything about being free. I was free enough before you took me, and I'm not going to fight until I see

Massa Lewis fighting, and then I fight for him.'"[179] The truth was that the Negro population of America just wasn't buying it when the same educated white people who agitated for emancipation left them without the basic necessities of life—employment, housing and education in free states. The news from escaped slaves in Canada wasn't any better. A lot of slaves were getting better treatment where they were from their owners.

The cause of emancipation didn't die with John Brown and his men. Cleveland's U.S. marshal who had ignored John Brown during the Anti-Slavery Convention was now very interested to trace his movements during that period in the Western Reserve. In Congress, a witch hunt commenced thereafter, seeking to assign blame for the assault upon Harpers Ferry to the Republican Party, of which Brown was a member. Governor Salmon P. Chase of Ohio was accused of providing money to Brown for the Harpers Ferry adventure, and on this pretext, Governor Wise of Virginia—where the whole state was up in arms—threatened to pursue anyone from Ohio that attempted to rescue John Brown and his men. While it was untrue that Chase had financially backed the Harpers Ferry venture because the twenty-five dollars in question had been a donation to the Free-Soil cause in Kansas, Republican after Republican was called on the carpet to explain their connections with Brown. Sympathizing with Brown's cause had become a crime, and indeed, the men of the North were drawing a very thin line between themselves and their hero. When Salmon P. Chase received Governor Wise's complaining letter, he disclaimed any knowledge of armed desperadoes gathering in Ohio for the purpose of rescuing John Brown and his men. Further, Chase pointed out that "the laws of the United States prescribed the mode in which persons charged with crime escaping into Ohio might be demanded and surrendered, and he added that Ohio under no circumstances would consent to the invasion of her territory by armed bodies from other States."[180] Everyone had the wind up. It was one of those situations where just about nobody was completely in the right. So Senator Benjamin F. Wade of Ohio told the United States Senate:

> *I ask you in the generosity of your hearts* [to] *separate and distinguish between approval of lawless invasion and sympathy for a hero taking his life in his hand and* [taking it] *up to the altar to offer it there a sacrifice to highest convictions of right Sir his* [intent] *was disinterested He is frequently spoken* [of] *as a common malefactor a vulgar murderer robber Sir he proposed nothing to himself His conduct was as disinterested as man's conduct can ever be but he was misguided…still the people of the North do*

not forget the great services that rendered to their cause to their relations their
friends who were in peril in the [state] *of Kansas nor can* [their] *human*
heart divest of a sense of that heroism which has characterized [Brown]
from the time that he was until the grave closed over him.[181]

There was no question but that the North and a great many of the North's antislavery leaders were warmly connected to John Brown.

In fact, the Western Reserve's Joshua Reed Giddings took immediate advantage in a speech given at the National Guard's Hall of Philadelphia just days after the Harpers Ferry incident to review the North's case against the South on their position regarding slavery, placing a lot of the blame for the Harpers Ferry incident squarely on the South. Reaching back into the American Revolution, he warmed his argument with defenders of liberty like Thomas Jefferson, John Adams, John Quincy Adams and John Randolph of Virginia to show that Brown was merely the spearhead of a movement that had been a long time coming—deservedly so—to the South. True, Giddings felt impelled to account for the three dollars he had donated to one of Brown's sons following a speech Brown gave in Jefferson County, Ohio, one Sunday afternoon, but he claimed to be as surprised as anyone regarding Brown's treasonable actions. Nobody quite believed him. When asked about his relationship with Giddings, John Brown refused to answer and implicate a friend who was clearly implicated. Yet Giddings warned that the people of his district in the Western Reserve of Ohio were indignant at the way they had been asked to stand off in their own state and watch helpless fugitives returned to slavery, and he knew what he was saying. Already, Ashtabula County of the Western Reserve had formed ranks to protect John Brown Jr. from extradition to Charleston, Virginia. They called themselves the "Black Stringers." These men used tin horn signals to warn John Brown Jr. of the approach of law enforcement officials on their way to arrest him and force him to testify at his father's trial.[182] Giddings's speech ends with a warning that Ohio would not continue to support the agendas of slave states, saying, "Our emancipation from the slave power must come and in the words of my illustrious and lamented friend John Quincy let me say it will come whether in peace or in blood I know not but whether in peace or in blood let it come."[183] No wonder it came to war.

The Melodeon Hall in the city of Cleveland was draped in mourning on December 2, 1859, and while a lot of Democratic churches refused to toll their bells for John Brown, a number of prominent politicians, judges and citizens gathered to mark their hero's passing.

CHAPTER 7
COPPERHEADS IN OHIO

In the summer of 1863 Confederate general John Hunt Morgan led his cavalry troop on a thousand-mile rampage from Tennessee into Kentucky, Indiana and all the way up into northeastern Ohio, expecting aid from Ohio's Peace Democrats, Butternuts or Copperheads, as they were called. He was disappointed to find that the Peace Democrats were precisely what they claimed to be—pacifists who wanted negotiated peace with the South and an end to Lincoln's despotic assumption of power. They had no intention of fighting alongside or supporting Rebel forces in any way. Morgan soon found himself trapped within enemy lines without aid. Therefore, when advance Rebel guards approached the town of Pomeroy in Meigs County, Ohio, they happened upon an unarmed man of seventy-four years of age crossing a field. At the sound of horses' hooves on the road, the old man turned to see who was coming. He was shot down: the ball entered his groin and thigh, breaking the bone at the joint. The soldiers left him unaided in the field while they ransacked his house for two hours, searching for valuables. The Rebel lieutenant who ordered him shot gave a half-hearted apology for the deed to the man's granddaughter, saying that he hadn't realized how old the man was when he gave the order. His justification: "You are all Abolitionists here aren't you?"

Morgan's Raid ended at Salinesville, Ohio, in southern Columbiana County, well into northeast Ohio just south of Western Reserve territory. The raid diverted a good number of Northern troops from the Battle of Gettysburg, weakening Northern positions, and two future presidents of the

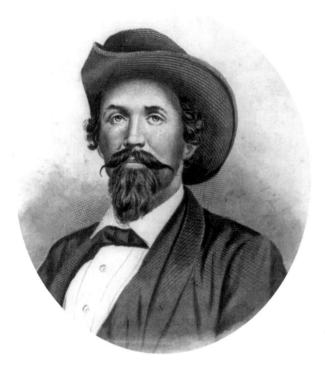

John Hunt Morgan.
Courtesy of the Library of Congress.

United States shared in the hunt for Morgan. This raid marked the deepest penetration of uniformed Confederate troops into Northern Territory during the Civil War. Hastily deployed Northern soldiers blocked Morgan's return to the south, which is what sent him so far north. The unarmed old man who died from his wound the week following the assault was Dr. William Norton Hudson, David Hudson's eldest son. Born in Goshen, Connecticut in 1789, Dr. Hudson's will left one-half of his estate remaining after his wife's death to "the Treasury of the United States provided that slavery shall at that time have been abolished in all parts of this land."[184]

Democratic newspapers in the Western Reserve like the *Cleveland Plain Dealer* had little sympathy for John Brown, recalling the stolen horses he had sold the summer he last visited Cleveland and decrying the tendency to eulogize a horse thief. For some reason, the town of Hudson fell silent over the execution of their native son, though his childhood friend Lora Case cherished the letter he received from Brown, which is reputed to be the last message to friends Brown wrote before his execution. Perhaps they were embarrassed, but there's no way to know for sure since the town failed to

John Brown letter to Lora Case. *Courtesy of Hudson Library and Historical Society, photographed by William Pelster.*

keep any newspapers from the time period. Perhaps the papers' absence is Puritan eloquence enough. A lot of people were distancing themselves from John Brown. Democrats were jumping all over Republicans for harboring Brown as a member.

In Ohio, therefore, a political vacuum was created that gave rise to a movement within the Democratic Party, favoring peace with the South over slavery, and a lot of European immigrants, who saw nothing but economic disaster for themselves should the Negro be freed, found a home in the Democratic Party. They were pretty fed up with Northern Puritans and their open abuse of Catholic immigrants. They saw both the war and abolitionism as a Protestant project. Further, American industrialists, by inviting these immigrants into the country as an alternative to slave labor, had created a situation in which the two groups were set in socioeconomic competition with one another for laboring jobs. Also, draft quotas preyed upon immigrant neighborhoods in disproportionate numbers that sent a firm message to these populations about how undervalued Catholic lives were in America. It was no great wonder, therefore, that they were less than eager to participate in the war.

What these immigrants failed to see were the dangers presented by arguments propounded by noisy Southern elements within the Democratic Party and what, if followed to a logical conclusion, these arguments might mean to Northern laborers. In a speech delivered before the United States Senate on December 14, 1859, Senator J.R. Doolittle of Wisconsin pointed out that there had been a material change in Southern attitudes toward the institution of slavery in America since the writing of the Declaration of Independence. When the constitution was written, Southern members admitted that slavery was a "necessary evil" that they hoped to eliminate as soon as a solution was found. Now the South was presenting slavery as a benevolent paternalistic institution that was as old as human civilization and could be compared to the relationship of a father and child or a husband's relationship with his wife—that it was all according to God's plan for his human creation's best interests. Doolittle refers to

> the Review of Mr. De Bow, the Richmond Enquirer, the Charleston Mercury, and the Richmond Examiner, and the book published by Mr. Fitzhugh, which was commended very generally by the leading Democratic press to people of the South, [which] take the ground and justify slavery, not because slaves are negroes—the descendants of Ham—but put it upon the broader ground, and as they allege, the only defensible ground on which slavery can rest, that the natural and normal condition of the laboring man is that of a slave; and that the true ground on which to reconcile this conflict is between capital and labor is, that capital should own its labor, and not hire it.[185]

The point repeated over and over again was that if the South got its way, slavery would not be limited by the color of a man's complexion, or his race. The South was claiming that, historically, slavery never had been so curtailed, and that the white laborer of the North need not feel exempted from being enslaved. Republicans latched onto this important point in the Democratic Party's rhetoric to warn the European immigrants attaching themselves to the Democratic party that once proslave interests achieved a stranglehold in American society, neither race nor ethnicity nor citizenship—whether naturalized or native born—would protect them from slavery's clutches.

Unfortunately, neither the immigrant nor the free black man was listening to all this high-browed rhetoric, and they failed to perceive their true danger. Likewise, the role Northern industrialists had played in creating dissention between free Negroes and European immigrants was invisible to them

because both groups were locked together in an economic battle for survival and had no time or effort for anything else. They saw only each other, never looking above their heads to the puppet masters pulling their strings. As war broke out and the government passed draft legislation, immigrants revolted because they were too poor to hire a man to fight in their place and had nothing to gain in risking their lives to free the Negro who would only compete in the job market with them, making their lives even harder. Many Democrats saw the war as a tool to free the slaves rather than a fight to save the Union. In addition, disruption to trade was a big drawback to war, especially along the Ohio River where commerce depended on access to the Mississippi River and to New Orleans. Those who had relatives in the South had no intention of fighting members of their own families, and pacifist faiths like the Quakers of southern Ohio felt that peaceful negotiation with the South had not been properly explored. Somewhere around 1861–1862, the term Copperhead appears to have been coined and came into popular use in the Midwest, connoting the Peace Movement within the Democratic Party with poisonous snakes. Demonization of Americans fighting to preserve the civil rights and principles of the United States Constitution was one step away. To those who have grown up hearing the term "Copperhead" applied to soldiers of the Confederate army, it is strange to learn that this term originated elsewhere. The purpose behind this appellation was to categorize the Peace Democrats as traitors to the Union and to silence them. It was just another implement used to ensure Republican control of the Congress. In other words, it was politics as usual.

The leader of the Democratic Party, Clement Laird Vallandigham, an Ohio member of the U.S. House of Representatives, was a primary force among the Peace Democrats who opposed the Civil War. The acknowledged leader of the Copperhead faction, Vallandigham believed in the Southern states' right to cede from the Union and supported legislation to make the Missouri Compromise permanent, allowing slavery to continue south of the thirty-six-degree, thirty-minute latitude line, extending the line all the way to the Pacific Ocean. Further, he opposed going to war to free the slaves because he felt that this would lead to Negro citizenship and suffrage. Also, it was clear to him that eastern industrialists were benefiting from this war at the expense of western states, imposing Puritanical political/religious domination that amounted to armed abolitionism. Businesses were gouged with high rail freight fees now that the Ohio and Mississippi Rivers were off limits. Midwesterners saw New England industrialists cashing in at the expense of the West.

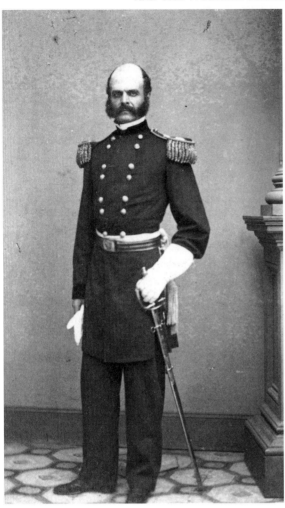

General Ambrose Burnside.
*Courtesy of the Library of
Congress.*

There was open and public derision for General Ambrose Burnside's General Order 38 that precipitated Vallandigham's arrest as a traitor to the Union. Democrats cried foul, insisting that General Order 38 violated the American citizen's right to freedom of speech, but President Lincoln sided with General Burnside. The order proclaimed that "the commanding general [i.e. General Burnside] publishes for the information of all concerned that hereafter all persons found within our lines who commit acts for the benefit of the enemies of our country will be tried as spies or traitors and if convicted will suffer death."[186] This included persons writing and/or carrying secret mail, persons seeking to join enemy troops and anyone spying for the enemy

or seeking to aid Rebel forces in any way. Vallandigham was arrested and tried by the military under the section that read, "The habit of declaring sympathies for the enemy will not be allowed in this Department [of Ohio]. Persons committing such offences will be at once arrested with a view to being tried as above stated or sent beyond our lines into the lines of their friends."[187] Vallandigham was not alone, but he was made an example of and sentenced to incarceration for the duration of the war. When the Peace Democrats protested the violation of their civil rights, President Lincoln responded this way:

> *Mr. Vallandigham avows his hostility to the war on the part of the Union; and his arrest was made because he was laboring, with some effect, to prevent the raising of troops; to encourage desertions from the army; and to leave the rebellion without an adequate military force to suppress it. He was not arrested because he was damaging the political prospects of the Administration, or the personal interests of the commander general, but because he was damaging the army...this gave the military constitutional jurisdiction to lay hands on him.*[188]

Lincoln allowed Vallandigham to be freed and sent to his friends in the South. From there, he escaped into Canada, seeking the Democratic nomination for governor of Ohio, and Hale's *Man Without a Country* was intended for publication in time for that election. Vallandigham's platform was "shall there be free speech, a free press, peaceable assemblages of the people, and a free ballot any longer in Ohio?"[189] It was a good question that reiterated the core beliefs of founding settlers. There wasn't a man, woman or child in the Western Reserve who didn't resonate the principles of free speech, free press and free men. Is it any wonder that there were those in the Western Reserve who treasured those freedoms that listened to him? His speech to the people of Ohio that was published from Canada rang with true American values that at least some of the Nutmegers could support.

Vallandigham had been dragged out of bed in the middle of the night, arrested in his nightshirt and sentenced by a military court under General Ambrose Burnside's General Order 38. After having been held in confinement for three weeks, he was deported to the Confederate States, and "there held as an alien enemy and prisoner of war though on parole fairly and honorably dealt with and given leave to depart an act possible only by running the blockade at the hazard of being fired upon by ships flying the flag of [his] own country."[190] All this, he claimed, occurred because he

spoke publicly in opposition to President Lincoln's war, which he believed would never be settled in his lifetime or that of his children's lifetimes due to the determination of the South to die rather than to submit. Vallandigham insisted that the issue was civil rights and freedom of speech, but the matter went well beyond that. It was about Lincoln's assumption of power in a way that amounted to dictatorship, negating the very principles of the American Revolution that Vallandigham decried. "In time of war," he says, "there is but one will supreme his will but one law military necessity and he the sole judge Military orders supersede the Constitution and military commissions usurp the place of the ordinary courts of justice in the land."[191] The idea that war could be used despotically to support the ruling party, which didn't have to answer for its behavior, criminalizing anyone who would question their leaders' actions, was appalling. His warning was clear: "If indeed all these be demanded by military necessity then believe me your liberties are gone and tyranny is perpetual."[192] There was no doubt that Vallandigham's rhetoric found favor with a number of Ohioans and was typical in his home district where a large number of Ohioans' family ties reached south of the Ohio River. He was proposed as a Democratic candidate for governor in Ohio, losing by 100,000 votes to John Brough, as a tide of patriotic enthusiasm greeted Union victories at Vicksburg and Gettysburg. Lincoln's response to Brough's win over Vallandigham was ecstatic. Having kept a

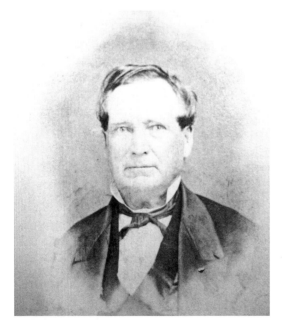

The Honorable Van R. Humphrey. *Courtesy of Hudson Library and Historical Society, photographed by William Pelster.*

strict eye on this election through the night, Lincoln's telegram credited God and Ohio, saying, "Glory to God in the highest Ohio has saved the Nation A Lincoln."[193] Nevertheless, throughout the war, a good number of Ohio citizens declared themselves to be Copperheads, principally in the region of Cincinnati and Dayton, Vallandigham's home territory. Men in Holmes County, members of pacifist faiths, assaulted recruitment officers.

In Hudson, at least one august gentleman, old Judge Van R. Humphrey, supported the Copperhead movement throughout the Civil War. Humphrey was, like David Hudson, born in Goshen, Connecticut. By May 1821, he had qualified to practice law there. He and his wife moved to Hudson that same year where he lived for the rest of his life, serving for a time as justice of the peace. Like many of the leading men of his generation, he served time in the Ohio House of Representatives. In addition, he was "President Judge of the Court of Common Pleas of the Third Judicial District for the term of seven years beginning in 1836 and ending in 1843."[194] The judge had been Republican, yet he became a firm supporter of Vallandigham and of the Copperhead movement, despite living next door to members of the Brown family and in the face of popular derision. He changed

The Van R. Humphrey House. *Courtesy of William Pelster, photographer.*

parties in the beginning years of the war over Lincoln's suspension of the U.S. Constitution. The old judge became a Democrat, which at the time amounted to the same thing as a Copperhead and/or a traitor, more or less. But his position was not all that unreasonable. A jurist like Humphrey was keenly aware that there was nothing in the constitution that made secession illegal, and he objected to a war devoted to the interests of a single segment of the population that brought such huge damages to the rest of the nation.

Originally, when the war struck, Judge Humphrey was a Republican eager to defend the Union. His war speech given at Streetsboro, Ohio—just a hop and a skip from Hudson—was full of support for the ruling party and the defense of the nation, as he said, "The ship of State is sinking, and he who in this dreadful emergency, would load it down with stale political dogmas, should do so at the hazard of his head. Let the commander guide and manage her through the storm, unembarrassed by passengers or crew."[195] He urged the people of Ohio to support Lincoln and not make leadership at such a critical time a greater burden than need be. In his opinion, however, the war was not at all about the Negro question. He pointed back into English history to highlight the South's motives for rebellion, saying,

> *It originated in the classes that settled this country. It began with the "Cavaliers" and "Roundheads," with an arrogance peculiar to the South, and pretending to belong to the former, they claim to be better blooded, better descended, more intellectual and more brave than the latter, who settled on the north; and one effect of the system of Slavery has been to augment and intensify this feeling of superiority…they still taunt us with a strong proclivity to "take off the hat in presence of Southern gentlemen."*[196]

In other words, the judge saw this as a class war, a socioeconomic competition between descendents of the common-born Puritans and descendents of English aristocrats. The South's problem with the North, he said, is "the increasing numbers, power and strength of the North, when they beheld the working of our free institutions, and saw that we should be likely to exact an equal participation in the management and emoluments of the Government, they could endure the connection no longer…'Rule or ruin' became their motto."[197] Humphrey's statement is interesting because the people of the Western Reserve were big believers in a classless society, and Ohio had been a pioneer in making common public schools available— the free institutions of learning to which the judge alludes and which he had played a foundational role in establishing. Meanwhile, the South had

historically kept learning privatized, hoarding education within their own class. That Humphrey saw the war as an extension of the English Civil War is illuminating. In addition, the judge was a strong Union man and a long-term member of the American Colonization Society. As far back as September 7, 1833, at a meeting held at the Congregational Church of Hudson, he sat on a committee that publicly condemned the evil of slavery while acknowledging that it was not within the power of Congress to dissolve the relationship of the master and the slave and sought the colonization of the slaves to Liberia in order maintain "the perpetual union of the United States."[198] In other words, like many others, the judge and other leaders of Hudson foresaw the threat to the Union over the slavery issue early on, that the two were irrevocably tied together.

But by 1863, the judge had changed parties, and his name was published on a list of Copperhead voters "furnished by the loyal men" of Hudson.[199] The list even included nine men who refused to vote either way, holding those on the list up to public derision. So how was it that the judge became a supporter of Clement Laird Vallandigham in the period leading up to Lincoln's second election to the office of president? The fact that the war had cost the country $2 billion and a half million lives was certainly an issue with him, but the judge felt that there was much more at stake than simply loss of life. It was a point of honor. He told the Democrats in late September 1863 that "the privileges of freemen have been wrested from you."[200] Here he is talking about Lincoln's support for General Order 38, the curtailing of the constitutional right to freedom of speech, and Lincoln's suspension of the writ of habeas corpus. The war was touted in support of the Union, he said, but he claimed that the Republican Party had been taken over by abolitionist supporters. "Mr. Lincoln," he said, "changed the entire policy of the war and adopted the John Brown policy…The policy now is not to put down the rebels and stop the war. The policy is to put down slavery, and if that can't be done with all the money and men in the country, why then let the country slide."[201] Humphrey told the audience that abolitionists in the army discarded Democratic generals, highlighting the Republican grab for power. Indeed, the Republican Party had dismissed any peace negotiations with the South as injudicious to the survival of their own party. Meanwhile, the cost of the war was enormous in money and in lives. Nevertheless, as the judge pointed out, the people had bigger issues with which to contend. Spies and detectives had been used to make all sorts of accusations against any person who fell under governmental displeasure. Juries and necessary witnesses had been discarded. Where there was neither

law nor independent judiciary, there was no liberty. No one knew that better than Judge Humphrey.

Naturally, the judge's rhetoric was not popular with everyone. In the days when Vallandigham sought the Democratic nomination for governor, Humphrey went out stumping for him. Dr. George P. Ashmun of Hudson, who had been assigned as surgeon to the Ninety-third OVI and was home on furlough, openly refused to shake hands with Judge Humphrey when he met him on the street in Hudson because of his Butternut affiliations. The judge's accusatory reply that Ashmun was taking pay from the government for his services to the war, costing the nation money, caught the doctor on the raw. So Dr. Ashmun took revenge by having Judge Humphrey hanged in effigy on the Hudson village green. Merrill Boodey of Peninsula, Ohio, reported that the town of Hudson sprouted another twenty Democrats in the judge's defense after that.[202] Nevertheless, there is no question that tempers were running high. When Humphrey addressed fifteen thousand

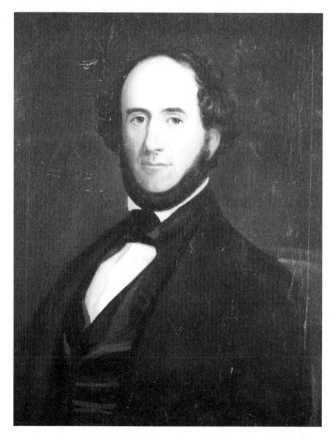

Dr. George Ashmun.
Courtesy of Hudson Library and Historical Society, photographed by William Pelster.

Village Green. *Courtesy of Hudson Library and Historical Society, photographed by William Pelster.*

Democrats in Akron, Ohio, in October 1863, he said, "Abolition leaders of the Republican party [in Akron organized] a lot of rowdies…for the sole purpose of mobbing and abusing every Democrat and every Democratic lady who attended the Convention."[203] There was no help and no apologies from law enforcement or from Republican leaders for this conduct. People were assaulted, and their Copperhead badges were torn from them.

But upon the judge's death of a sudden stroke, men of the local bar association went on record in newspapers in every Western Reserve county where Judge Humphrey had presided—Ashtabula, Portage, Ravenna and Summit—praising his ethical service to the judiciary and making no mention of his politics whatsoever. As a leader in the Democratic Party, his political platform had been founded on freedom of speech, liberty of the press and an objection to Lincoln's suspension of the writ of habeas corpus.[204] There had never been any question of the good man's support for the U.S. Constitution, the Union and the rule of law. Further, it is to be remembered that Judge Humphrey's son had been one of the first to answer the call to arms on behalf of the Union, despite any Democratic leanings, and that brings up another issue.

The Peace Democrats/Copperheads weren't the only Rebels with which the state of Ohio had to contend. There were other varieties of Copperheads— as in Rebel soldiers not in uniform and active sympathizers— about which to worry. These were difficult to distinguish from Peace Democrats and represented a real hazard. Profiling Democrats as potential enemy agents appeared to have been a tool in the bag. In a letter to Governor David Tod dated June 10, 1862, Judge Humphrey complained that when the Western Reserve College cadets left Hudson for Columbus, his son was first lieutenant. It seems that the young man had not been awarded a position of rank when he reported to active service. He was assigned to the Camp Chase prisoner of war camp in Columbus, Ohio, rather than being sent to battle where he might be rewarded with a field promotion and an increase in salary. Humphrey's concerns were both patriotic and monetary since his son needed to earn money to help him finish his education at the Western Reserve College, but he felt that his son's "Democratic proclivities" had caused his character and abilities to be overlooked.[205] In other words, it wasn't just the country that was being run by Northern Republicans, it was affecting military staffing and preferment. The young man was paying a price for his father's politics. How could the North win the war when the two political parties could not cooperate on the battlefield? Distrust between Republicans and Democrats was splitting the nation as surely as the war itself, and it shed light on the judge's remarks to Ashmun as an irrepressible touch of frustration and jealousy. Nevertheless, there was no doubt that knowing friend from foe under these circumstances was difficult. Lincoln was right to be concerned that these Peace Democrats might become a cat's paw for the Confederacy. In fact, the Confederacy at one time harbored hopes of support from Peace Democrats. A cacophony of Confederate agents and sympathizers had gathered along the U.S. and Canadian border in hopes of using these Peace Democrats to damage the Union cause and/or at the very least block Lincoln's reelection. Under the guidance of James Buchanan's late secretary of the interior, Jacob Thompson, the plan was to organize support from these Democrats, enabling the Confederacy to seize and hold the states of Illinois, Indiana and Ohio. It was expected that Missouri and Kentucky would then join the Confederate cause. Thompson believed that once this was accomplished, the war would end in sixty days;[206] however, attempts to win over the public failed, as a wave of patriotism followed the nomination of General George McClellan to be the Democratic candidate for the presidency.

Thompson abandoned his political campaign plans to collude with a Confederate officer from Virginia by the name of John Yates Beall. Beall

would lead a team of twenty-five Confederates to take "passage from Sandwich in Canada on board the *Philo Parsons*, an unarmed merchant vessel," with a view toward liberating Confederate prisoners incarcerated on Johnson's Island off the shores of Sandusky, Ohio.[207] On September 19, 1864, the old men, women and children of Put-in-Bay out in Lake Erie were beginning their workday in the vineyards and orchards of Kelly's Island. (The able-bodied men of the island were serving as Union troops.) That morning the steamer *Island Queen* had left for its daily trip to Sandusky, and the only hint of what was coming was news of strange visitors to the island days before who had expressed Copperhead sympathies. The island had its share of Peace Democrats, and the people of Kelly's Island thought little of the incident until "the steamer *Philo Parsons* of the Detroit Island & Sandusky line landed at Wehrle's dock on Middle Bass [Island] distant a mile or so from the Bay" and remained docked without continuing on to Detroit.[208] It was supposed to come across to Kelly's Island. Soon the ship was joined by the *Island Queen*, but both ships remained docked rather than continuing on their set routines. People expecting packages and mail gave up wondering and went home to bed; however, the islanders were awakened in the night with information that "the steamers *Island Queen* and *Philo Parsons* are in the hands of the rebels Secrete your money and valuables and if you have fire arms or ammunition in the house get them together and hurry to the Bay."[209] Captain George Magle, who had been a passenger on the *Island Queen*, had managed to row across to them to spread the warning. The Rebel force intended to capture the *Michigan*, a gunboat at port in Sandusky to guard the Confederate prisoner of war camp on Johnson's Island and free the prisoners there. From there they intended to sweep through Ohio's other prisoner of war camps to free Confederate soldiers.

At this time, John Brown Jr. was living quietly on Kelly's Island, having served a year in the Union army before becoming disabled. He still held a personal arsenal of weapons of his own and from his father consisting of muskets, breech-loading rifles, Springfield rifles, shotguns, revolvers and horse pistols.[210] He was immediately elected to lead the island's defenders, and arrangements were made to get word to Johnson's Island. Meanwhile, the island's Peace Democrats took shelter in the island's limestone caves, having no intention of giving the aid that these Rebel forces looked for from them;[211] however, on the following morning, the *Philo Parsons* was seen heading for the Detroit River, so it was assumed that the attempt to liberate Johnson's Island had failed. The conspirators were trying to get away. "A piece of paper accidentally or intentionally dropped containing plans of

the conspirators," warned the officers of the *Michigan* and the guards at Johnson's Island of the plot in time.[212] There is little doubt, though, that had this plot succeeded, perhaps with collusion from Peace Democrats, the results would have been devastating to the Union cause.

NOTES

1. THE LAND AND THE PEOPLE OF THE WESTERN RESERVE

1. Villard, *John Brown*, 17–18.
2. Caccamo, "Underground Railroad-Hudson."
3. Upton, *History of the Western Reserve*, 7.
4. Washington and Sparks, *The Writings of George Washington*, 178.
5. Ibid.
6. Ibid.
7. Metcalf, "Historical Papers," 2.
8. Mills, *The Story of the Western Reserve*, 107.
9. Wood, "'Build, Therefore, Your Own World,'" 32.
10. Ibid., 36.
11. Hudson, "Some Account of the Religious Exercises of David Hudson," 295.
12. Ibid., 299.
13. Ibid., 300.
14. *Ohio Observer and Telegraph*, June 9, 1832.
15. Oviatt, *Account 1*.
16. Cackler, *"Recollections of an Old Settler,"* 41.
17. Ibid.
18. "Appointment of David Hudson as Postmaster of Hudson."
19. *Ohio Observer and Telegraph*, July 28, 1831.
20. Adams, *Contributions to American Educational History*, 117.

21. Rice, *Pioneers of the Western Reserve*, 85.

22. Ibid., 87.

2. Black Laws and the Evolution of the Underground Railroad in Ohio

23. *Cleaveland Herald*, November 14, 1820.

24. Dunn, *Indiana*, 212.

25. Quillin, *The Color Line in Ohio*, 16.

26. Ibid., 33.

27. Ibid., 23.

28. Engle and Engle, "Revised Final House Report," 18.

29. Cochran, "The Western Reserve and the Fugitive Slave Law," 80.

30. Cuyahoga County Archives Box 2, Vol. 4, 517–19.

31. *Cleaveland Herald*, November 14, 1820; Ibid., March 20, 1821.

32. Ibid., March 20, 1821.

33. Siebert and Hart, *The Underground Railroad*, 461.

34. Ibid., 458.

35. Ibid.

36. Chaddock, *Ohio Before 1850*, 107.

37. Sanborn, *Recollections of Seventy Years*, 249.

38. Siebert and Hart, *The Underground Railroad*, 77.

39. Ibid., 458.

40. Ibid.

41. Ibid.

42. Ibid., 267.

43. Caccamo, *Hudson, Ohio and the Underground Railroad*, 14.

44. Lane, *Fifty Years and Over*, 828.

45. Mathews, *Ohio and Her Western Reserve*, 174.

46. Lane, *Fifty Years and Over*, 828.

47. Cochran, "The Western Reserve and the Fugitive Slave Law," 121.

3. The African Colonization Scheme and the Western Reserve College

48. Green, *Four Sermons*, 65–66.

49. Ibid., 60.

50. Wright, *The Sin of Slavery*, 19.
51. Jordan and Walsh, *White Cargo*, 191.
52. Moya Pons, *History of the Caribbean*, 226–28.
53. Beecher, *Conflict of Northern and Southern Theories*, 10
54. Ibid.
55. Sherwood, "Movement in Ohio," 26.
56. Ibid., 45.
57. Martineau, *The Martyr Age*, 2.
58. Martineau, *Retrospect of Western Travel*, 191–92.
59. Martineau, *Society in America*, 118.
60. Ibid., xii.
61. Martineau, *The Martyr Age*, 2.
62. Atwater, *A History of the State of Ohio*, 323.
63. Diary of David Hudson Jr.
64. Epistle to Philemon 1:10–16.
65. *Ohio Star*, July 28, 1831.
66. Ibid., October 14, 1830.
67. Ibid., July 28, 1831.
68. Ibid.
69. Green, *Four Sermons*, 5.
70. Ibid., 12.
71. Ibid., 5.
72. Ibid., 6, 7.
73. Ibid., 23.
74. Ibid., 23, 25, 26.
75. Ibid., 2, 19, 30.
76. Ibid., 56.
77. Ibid., 51.
78. Case, *Hudson of Long Ago*, 28.
79. Ibid.
80. Ibid., 26, 27.
81. Records of the Free Congregational Church.
82. Ibid.

4. The Rise of Abolitionism

83. Martineau, *The Martyr Age*, 34, 38, xi.
84. Case, *Hudson of Long Ago*, 53.

85. Jordan, "Quakers, 'Comeouters,' and the Meaning of Abolitionism," 594. See also Coffin, *Reminiscences of Levi Coffin*, 227.

86. Ibid.

87. Ibid., 53–54.

88. Sanborn, *The Life and Letters of John Brown*, 33.

89. Martineau, *Retrospect of Western Travel*, 38.

90. Martineau, *Society in America*, 116.

91. Martineau, *The Martyr Age*, 21.

92. Martineau, *Society in America*, 117.

93. Martineau, *The Martyr Age*, v.

94. Case, *Hudson of Long Ago*, 27.

95. Cutler, *A History of Western Reserve College*, 43.

96. Martineau, *The Martyr Age*, v–xix.

97. Ibid.

98. Case, *Hudson of Long Ago*, 27.

99. Records of the Free Congregational Church.

100. Case, *Hudson of Long Ago*, 31–33.

101. *Cleveland Observer*, April 17, 1839.

102. Ibid.

103. *National Anti-Slavery Standard*, August 19, 1847.

104. Washington, *Frederick Douglass*, 118.

105. Ibid., 119.

106. Ibid.

107. Ibid.

108. *Cleveland Observer*, April 17, 1839.

109. Ibid.

110. Ibid.

111. Fairchild, *Oberlin*, 85.

112. Smith, *The Liberty and the Free Soil Parties*, 227.

113. *Cleveland Daily Plain Dealer*, October 28, 1850.

114. Ibid., July 29, 1851.

115. Tuckerman, *William Jay*, 142–43.

116. *Cleveland Daily True Democrat*, October 17, 1850.

117. May, *The Fugitive Slave Law*, 138–39.

118. Giddings, "Pacificus," 1.

119. Ibid.

120. Ibid., 2.

121. Ibid.

122. Ibid., 3.

123. Ibid.
124. Wilson and Hunt, *History of the Rise and Fall*, 251.

5. Frederick Douglass and the Defense of Negro Humanity

125. Case, *Hudson of Long Ago*, 29–30.
126. Ibid.
127. Gregory, *Frederick Douglass the Orator*, 107.
128. Douglass, *Life and Times of Frederick Douglass*, 456.
129. *Hudson Observer and Examiner*, July 19, 1854.
130. Douglass, *Life and Times of Frederick Douglass*, 456.
131. Early Settlers Association of Cuyahoga County, *Annals of the Early Settlers*, 495.
132. Ibid.
133. Ibid., 496.
134. Ibid.
135. Ibid.
136. Ibid.
137. *Ohio Observer and Register*, July 19, 1854.
138. Scholes, *Glimpses of the Ages*, 5.
139. Carroll, *"The Negro a Beast."*
140. Douglass, *Claims of the Negro*, 60.
141. Ibid., 7.
142. Ibid.
143. Ibid., 9.
144. Ibid., 12.
145. Ibid., 13.
146. Ibid.
147. Ibid., 14.
148. Ibid., 16.
149. Giddings, "Pacificus," 8.
150. Ibid.
151. Ibid.
152. Douglass, *Claims of the Negro*, 34.
153. Ibid., 35.
154. Ibid.

6. Fire in the Hole

155. *Cleveland Plain Dealer*, September 13, 1858.

156. *Ohio Observer and Register*, May 31, 1854.

157. Ibid., June 28, 1854.

158. Ibid.

159. Ibid., June 7, 1854.

160. Ibid., July 12, 1854.

161. Ibid.

162. Ibid., August 9, 1854.

163. Moya Pons, *History of the Caribbean*, 226–28.

164. *Ohio Observer and Register*, June 28, 1854.

165. Ibid.

166. Gardner, *Life of Stephen A. Douglas*, 79.

167. *Ohio Observer and Register*, June 28, 1854.

168. Ibid., July 19, 1854.

169. Ibid., May 31 1854.

170. Bridgman and Parsons, *With John Brown in Kansas*, 9.

171. Ibid., 12.

172. Ibid., 18.

173. American Anti-Slavery Society, *The Anti-Slavery History*, 289.

174. Ibid.

175. Brown, *The Truth at Last*, 4.

176. *New York Times*, May 28, 1859.

177. American Anti-Slavery Society, *The Anti-Slavery History*, 69.

178. Ibid., 68.

179. Zittle and Zittle, *A Correct History*, 41.

180. Villard, *John Brown*, 524.

181. Wade, *Invasion of Harper's Ferry*, 4.

182. Early Settlers Association of Cuyahoga County, *Annals of the Early Settlers*, 142.

183. Voss, *Reuben 1859*, 235.

7. Copperheads in Ohio

184. Senour, *Morgan and His Captors*, 176–77.

185. Dixon, *Speech of Hon. James Dixon*, 16. This book contains the speech of the Honorable J.R. Doolittle of Wisconsin, delivered in the United

States Senate, December 14, 1859. This quote comes from page two of the speech. See also Tewell, "A Difference of Complexion," 235–54.

186. Woodbury, *Major General Ambrose E. Burnside*, 265.

187. Ibid., 266.

188. Selby, *The Life, Stories, and Speeches*, 267.

189. Vallandigham, *Speeches, Arguments, Addresses, and Letters*, 439.

190. Ibid., 438.

191. Ibid., 439.

192. Ibid.

193. Browne, *The Every-Day Life of Abraham Lincoln*, 603.

194. Perrin and Graham, *History of Summit County*, 304.

195. *Portage County Democrat*, September 3, 1862.

196. Ibid.

197. Ibid.

198. American Colonization Society, *The African Repository*, 246.

199. List owned by the Hudson Library and Historical Society.

200. *Cleveland Plain Dealer*, October 1, 1863.

201. Ibid.

202. Bishop and Bishop, *The Civil War Letters*, 50.

203. *Cleveland Plain Dealer*, October 8, 1863.

204. Ibid., June 23, 1864.

205. Humphrey, Letter to Governor David Tod.

206. Nicolay and Hay, "Abraham Lincoln: A History," 556.

207. Ibid., 557.

208. Thorndale, *Sketches and Stories*, 70.

209. Ibid., 71–72.

210. Ibid., 72.

211. Ibid., 73.

212. Ibid., 80.

References

Books

Adams, Herbert Baxter. *Contributions to American Educational History*. Vol. 12. Washington, D.C.: Government Printing Office, 1890.

American Anti-Slavery Society. *The Anti-Slavery History of the John-Brown Year; Being the Twenty-Seventh Annual Report of the American Anti-Slavery Society*. New York: American Anti-Slavery Society, 1861.

American Colonization Society. *The African Repository, and Colonial Journal*. Vol. 9. Washington, D.C.: American Colonization Society, 1825.

Ariel. *The Negro: What Is His Ethnological Status? Is He the Progeny of Ham? Is He a Descendant of Adam and Eve? What Is His Relation to the White Race?* Cincinnati, OH: Published for the Proprietor, 1872.

A Tribute of Respect, Commemorative of the Worth and Sacrifice of John Brown, of Ossawatomie: It being a Full Report of the Speeches Made and the Resolutions Adopted by the Citizens Cleveland, at a Meeting Held in the Melodeon, on the Evening of the Day on Which John Brown Was Sacrificed by the Commonwealth of Virginia: Together with a Sermon, Commemorative of the Same Sad Event. Cleveland, OH: self-published, 1859.

Atwater, Caleb. *A History of the State of Ohio: Natural and Civil*. 1st ed. Cincinnati: Glezen & Shephard, 1838.

Beecher, Henry Ward. *Conflict of Northern and Southern Theories of Man and Society*. Rochester, NY: A. Strong & Co., 1855.

Bishop, Robert P., and Jeanette K. Bishop. *The Civil War Letters of Sgt. Levi Barker Boodey Co. C, 115th O.V.I. and Family.* Peninsula, OH: Robert P. & Jeanette K. Bishop, 2008.

Brewster, W.H., and B.B. Brewster. *John Brown: A Brief Biography with Letters by the Liberator.* N.p.: G.W. Hughes, 1900.

Bridgman, Edward Payson, and Luke Fisher Parsons. *With John Brown in Kansas: The Battle of Osawatomie.* Madison, WI: J.N. Davidson, 1915.

Brown, George W. *The Truth at Last: History Corrected; Reminiscences of Old John Brown; Thrilling Incidents of Border Life in Kansas; With an Appendix, Containing Statements and Full Details of the Pottawotomie Massacre, by Gov. Crawford, Col. Blood, Jas. Townsley, Col. Walker, and Others.* Rockford, IL: A.E. Smith, 1880.

Brown, John, and F.B. Sanborn. *The Life and Letters of John Brown, Liberator of Kansas and Martyr of Virginia.* Concord, MA: F.B. Sanborn, 1910.

Browne, Francis F. *The Every-day Life of Abraham Lincoln: A Biography from an Entirely New Standpoint, with Fresh and Invaluable Material: Lincoln's Life and Character Portrayed by Those Who Knew Him. Estimates and Impressions of Distinguished Men.* New York and St. Louis, MO: N.D. Thompson Pub. Co., 1886.

Caccamo, James F. *Hudson, Ohio and the Underground Railroad.* Hudson, OH: Friends of the Hudson Library, 1992.

Cackler, Christian. *"Recollections of an Old Settler." Stories of Kent and Vicinity in Pioneer Times.* Kent, OH: Kent Courier, 1904.

Carroll, Charles. *"The Negro a Beast"; or, "In the Image of God"; The Reasoner of the Age, the Revelator of the Century! The Bible As It Is! The Negro and his Relation to the Human Family!...The Negro not the Son of Ham.* St. Louis, MO: American Book and Bible House, 1910.

Case, Lora. *Hudson of Long Ago: Progress of Hudson during the Past Century, Personal Reminiscences of an Aged Pioneer.* Hudson, Ohio: Hudson Library and Historical Society, 1897. Reprint, 1963.

Chaddock, Robert F., Ph.D. *Ohio Before 1850: A Study of the Early Influence of Pennsylvania and Southern Populations in Ohio.* New York: Columbia University, 1908.

Cherry, Peter P., and Russell L. Fouse. *The Western Reserve and Early Ohio.* Akron, OH: R.L. Fouse, 1921.

Coffin, Levi. *Reminiscences of Levi Coffin, the Reputed President of the Underground Railroad: Being a Brief History of the Labors of a Lifetime in Behalf of the Slave, with the Stories of Numerous Fugitives, who Gained their Freedom through his Instrumentality, and Many Other Incidents.* Cincinnati, OH: R. Clarke & Co, 1880.

Cutler, Carroll. *A History of Western Reserve College: During Its First Half Century, 1826–1876.* Cleveland, OH: Crocker's Publishing House, 1876.

Dixon, James. *Speech of Hon. James Dixon, of Conn., Delivered in the Senate of the United States, Wednesday, June 25, 1862, on his Resolution Respecting the Legal Effect of Acts or Ordinances of Secession.* Washington, D.C.: Scammell & Co., 1862.

Douglass, Frederick. *Claims of the Negro, Ethnologically Considered: an Address before the Literary Societies of Western Reserve College, at Commencement, July 12, 1854.* Rochester, NY: Press of Lee, Mann, 1854.

————. *Life and Times of Frederick Douglass.* Hartford, CT: Park Publishing, 1882.

DuBois, W.E.B. *John Brown.* Philadelphia: G.W. Jacobs & Company, 1909.

Dunn, Jacob Piatt. *Indiana.* Boston: Houghton, Mifflin and Co., 1888.

Fairchild, James Harris. *Oberlin: The Colony and the College, 1833–1883.* Oberlin, OH: E.J. Goodrich, 1883.

Gardner, William. *Life of Stephen A. Douglas.* Boston, MA: Roxburgh Press, 1905.

Green, Beriah. *The Chattel Principle, the Abhorrence of Jesus Christ and the Apostles; or, No Refuge for American Slavery in the New Testament.* Anti-Slavery Examiner 12. New York: American Anti-slavery Society, 1839.

————. *Four Sermons, Preached in the Chapel of the Western Reserve College, on Lord's Day, November 13th and 25th, and December 2nd and 9th, 1832.* Cleveland, OH: Printed at the Office of the Herald, 1833.

————. *Sermons and Other Discourses: With Brief Biographical Hints.* New York: S.W. Green, 1860.

————. *Things for Northern Men to Do: A Discourse Delivered Lord's Day Evening, July 17, 1836, in the Presbyterian Church, Whitesboro, N.Y.* New York: n.p., 1836.

Gregory, James Monroe. *Frederick Douglass the Orator: Containing an Account of his Life; His Eminent Public Services; His Brilliant Career as Orator; Selections from his Speeches and Writings.* Springfield, MA: Willey & Co., 1893.

Hatcher, Harlan. *The Western Reserve: The Story of New Connecticut in Ohio; Black Squirrel Books.* Kent, OH: Kent State University Press and Western Reserve Historical Society, 1991.

Haydn, Hiram Collins. *Western Reserve University from Hudson to Cleveland, 1878–1890; A Historical Sketch.* Cleveland, OH: Western Reserve University, 1905.

Howe, Henry. *Historical Collections of Ohio…An Encyclopedia of the State: History both General and Local Geography…Sketches of Eminent and Interesting Characters, etc., with Notes of a Tour over it in 1886.* Columbus, OH: H. Howe & Son, 1889.

Jordan, Don, and Michael Walsh. *White Cargo: the Forgotten History of Britain's White Slaves in America.* Washington Square, NY: New York University Press, 2008.

Lane, Samuel A. *Fifty Years and Over of Akron and Summit County [O.].* Akron, OH: Beacon Job Department, 1892.

Martineau, Harriet. *The Martyr Age of the United States of America With an Appeal on Behalf of the Oberlin Institute in Aid of the Abolition of Slavery.* Newcastle upon Tyne: Finlay and Charlton, 1840.

————. *Retrospect of Western Travel.* London: Saunders and Otley, 1838.

————. *Society in America.* Vol. 2. New York: Saunders and Otley, 1837.

Mathews, Alfred. *Ohio and Her Western Reserve.* New York: D. Appleton and Company, 1902.

May, Samuel. *The Fugitive Slave Law and Its Victims.* Anti-slavery Tracts 15. New York: American Anti-Slavery Society, 1861.

Mills, William S. *The Story of the Western Reserve of Connecticut.* New York: Brown & Wilson Press, 1910.

Moya Pons, Frank. *History of the Caribbean: Plantations, Trade, and War in the Atlantic World.* Princeton, NJ: Markus Wiener Publishers, 2007.

Nott, Josiah Clark, George R. Gliddon, Samuel George Morton, Louis Agassiz, William Usher and Henry S. Patterson. *Types of Mankind: or, Ethnological Researches: Based upon the Ancient Monuments, Paintings, Sculptures, and Crania of Races, and upon Their Natural, Geographical, Philological and Biblical History, Illustrated by Selections from the Inedited Papers of Samuel George Morton and by Additional Contributions from L. Agassiz, W. Usher, and H.S. Patterson.* Philadelphia, PA: J.B. Lippincott, Grambo, 1854.

Perrin, William Henry, and A.A. Graham. *History of Summit County, With an Outline Sketch of Ohio.* Chicago, IL: Baskin & Battey, 1881.

Quillin, Frank Uriah. *The Color Line in Ohio; a History of Race Prejudice in a Typical Northern State.* Ann Arbor, MI: G. Wahr, 1913.

Redpath, James. *The Public Life of Capt. John Brown.* Boston, MA: Thayer and Eldridge, 1860.

Rice, Harvey. *Pioneers of the Western Reserve.* Boston, MA: Lee and Shepard, 1890.

————. *Sketches of Western Reserve life.* Cleveland, OH: W.W. Williams, 1885.

Sanborn, F.B. *The Life and Letters of John Brown: Liberator of Kansas, and Martyr of Virginia.* Boston, MA: Roberts Brothers, 1891.

————. *Recollections of Seventy Years.* Boston, MA: R.G. Badger, 1909.

Scholes, Theophilus E. Samuel. *Glimpses of the Ages; or, the "Superior" and "Inferior" Races, So-called, Discussed in the Light of Science and History.* London: J. Long, 1905.

Selby, Paul. *The Life, Stories, and Speeches of Abraham Lincoln; a Compilation of Lincoln's Most Remarkable Utterances, with a Sketch of his Life.* Chicago, IL: G.M. Hill Co., 1901.

Senour, the Reverend F. *Morgan and His Captors.* Cincinnati, OH: C.F. Vent & Co., 1865.

Siebert, Wilbur Henry, and Albert Bushnell Hart. *The Underground Railroad from Slavery to Freedom.* New York: Macmillan Co., 1898.

Smith, Theodore C. *The Liberty and the Free Soil Parties in the Northwest.* Vol. 6 of Harvard Historical Studies. London and Bombay: Longman's Green and Co., 1897.

Stowe, Harriet Beecher. *A Key to Uncle Tom's Cabin; Presenting the Original Facts and Documents upon which the Story Is Founded. Together with Corroborative Statements Verifying the Truth of the Work.* Boston, MA: J.P. Jewett & Co., 1853.

Thorndale, Theresa. *Sketches and Stories of the Lake Erie Islands.* Sandusky, OH: I.F. Mack & Brother, 1898.

Tuckerman, Bayard. *William Jay and the Constitutional Movement for the Abolition of Slavery, by Bayard Tuckerman, with a Preface by John Jay.* London: J.R. Osgood, McIlvaine and Co., 1893.

Upton, Harriet Taylor. *History of the Western Reserve.* Chicago, IL: Lewis Publishing Co., 1910.

Vallandigham, Clement L. *Speeches, Arguments, Addresses, and Letters of Clement L. Vallandigham.* New York: J. Walter, 1864.

Villard, Oswald G. *John Brown, 1800–1859: A Biography Fifty Years After.* Boston: Houghton Mifflin Company, 1910.

Vose, Reuben. *Reuben Vose's Wealth of the World Displayed.* New York: R. Vose, 1859.

Wade, B.F. *Invasion of Harper's Ferry: Speech of Hon. Benjamin F. Wade, of Ohio: Delivered in the United States Senate, December 14, 1859.* Washington: Buell & Blanchard, 1859.

Washington, Booker T. *Frederick Douglass.* Vol. 3. Philadelphia, PA: G.W. Jacobs, 1907.

Washington, George, and Jared Sparks. *The Writings of George Washington Being His Correspondence, Addresses, Messages, and Other Papers, Official and Private, Selected and Published from the Original Manuscripts; With a Life of the Author, Notes and Illustrations.* Vol. 9. Boston, MA: Ferdinand Andrews, 1839.

Wilson, Henry, and Samuel Hunt. *History of the Rise and Fall of the Slave Power in America.* Boston, MA: Houghton Mifflin, 1872.

Wilson, James Grant, and John Fiske. *Appleton's Cyclopædia of American Biography.* Vol. 4. New York: D. Appleton and Co., 1888.

Woodbury, Augustus. *Major General Ambrose E. Burnside and the Ninth Army Corps: A Narrative of Campaigns in North Carolina, Maryland, Virginia, Ohio, Kentucky, Mississippi and Tennessee, During the War for the Preservation of the Republic.* Providence, RI: S.S. Rider & Brother, 1867.

Wright, Elizur, Jr. *The Sin of Slavery, and Its Remedy; Containing Some Reflections on the Moral Influence of African Colonization.* New York: Self-published, 1833.

Zittle, John H., and Hanna Minnie Weaver Zittle. *A Correct History of the John Brown Invasion at Harper's Ferry, West Va., Oct. 17, 1859.* Hagerstown, MD: Mail Publishing Co., 1905.

PAPERS

"Appointment of David Hudson as Postmaster of Hudson." Documents of David Hudson, Hudson Library and Historical Society, Inc.

Caccamo, James F. "Underground Railroad Sites in Hudson, Ohio," 2010. Hudson Library and Historical Society, Inc. http://www.hudsonlibrary.org/HistoricalSociety/UGRRHudson.html.

Cochran, William C. "The Western Reserve and the Fugitive Slave Law, a Prelude to the Civil War. William C. Cochran, L.L.D," January 1920. Publication No. 101 Collections. Western Reserve Historical Society.

Cuyahoga County Archives. Box 2, Vol. 4, 517-519.

Diary of David Hudson Jr. Hudson Library and Historical Society, Inc.

Documents of David Hudson. Hudson Library and Historical Society, Inc.

Engle, Roger and Ann Engle. "Revised Final House Report."

Giddings, Joshua Reed. "Pacificus, the Rights and Privileges of the Several States in Regard to Slavery: Being a Series of Essays, Published in the Western Reserve Chronicle, (Ohio), After the Election of 1842." Samuel J. May Anti-Slavery Collection, Cornell University Library, http://ebooks.library.cornell.edu/cgi/t/text/text-idx?page=home;c=mayantislavery. (accessed May 16, 2011).

Humphrey, Van R. Letter to Governor David Tod Dated June 10, 1862. Ohio Historical Society Library/Archives, http://ohsweb.ohiohistory.org/index.shtml.

Metcalf, Emily. "Historical Papers Delivered at the Centennial Anniversary of the First Congregational Church of Hudson, Ohio. September 4, 1902." Hudson Library and Historical Society Archives.

Oviatt, Heman. "Account 1." Hudson Library and Historical Society.

Records of the Free Congregational Church of Hudson Organized October 7th A.D. 1842. Hudson Library and Historical Society, Inc.

Periodicals

Atkinson, Edward. "The Negro a Beast." *North American Review* 181, no. 585 (August 1905).

Cleveland Daily True Democrat.

Cleaveland Herald.

Cleveland Leader.

Cleveland Plain Dealer.

Early Settlers Association of Cuyahoga County. *Annals of the Early Settlers Association of Cuyahoga County, Ohio* 5, no. 1 (1904).

Goodheart, Laurence B. "Abolitionists as Academies: The Controversy at Western Reserve College, 1832–1833." *History of Education Quarterly* 22, no. 4 (Winter 1982).

Hudson, David. "Some Account of the Religious Exercises of David Hudson." *New-York Missionary Magazine, and Repository of Religious Intelligence* 2 (1900).

Hudson Observer and Examiner.

Jordan, Ryan. "Quakers, 'Comeouters,' and the Meaning of Abolitionism in the Antenbellium Free States." *Journal of the Early Republic* 24, no. 4 (Winter 2004).

National Anti-Slavery Standard.

New England Magazine.

New York Times.

Nicolay, John C., and John Hay. "Abraham Lincoln: A History; the Chicago Surrender—Conspiracies in the North—Lincoln and the Churches." *Century Illustrated Monthly Magazine* 38, no. 4 (August, 1889).

Ohio Observer and Register.

Ohio Observer and Telegraph.

Ohio Star.

Portage County Democrat.

Sherwood, Henry Noble. "Movement in Ohio to Deport the Negro and Two Pamphlets on Colonization." *Quarterly Publication of the Historical and Philosophical Society of Ohio* 7, nos. 2, 3 (June and September 1912).

Sherwood, H.N. "Early Deportation Projects." *Mississippi Valley Historical Review* 2, no. 4 (March 1916).

Tewell, Jeremy J. "A Difference of Complexion: George Fitzhugh and the Birth of the Republican Party." *Historian* 73, no. 2 (Summer 2011).

Western Reserve Historical Society. *Publication* (1870).

Wood, Joseph S. "'Build, Therefore, Your Own World': The New England Village as Settlement Ideal." *Annals of the Association of American Geographers* 81, no. 1 (March 1991).

ABOUT THE AUTHOR

Mae Pelster is a lifelong resident of the Connecticut Western Reserve in Ohio—where she and her husband, William, have spent many years hiking the canal towpaths of the Cuyahoga Valley—and is the mother of three wonderful children: Ben, Laura and Ellice. She and her family have lived in the city of Hudson for almost seventeen years. A member the National History Honor Society Phi Alpha Theta, Mae received a bachelor's of arts degree from Hiram College where she majored in humanities and fine arts with an emphasis on American history, British history and literature. She also pursued a minor in writing at Hiram College, graduating summa cum laude alongside her youngest daughter, Ellice. Mae is currently pursuing a master's of fine arts in writing for youth and children at Vermont College of Fine Arts and is scheduled to graduate in the summer of 2012.

Visit us at
www.historypress.net